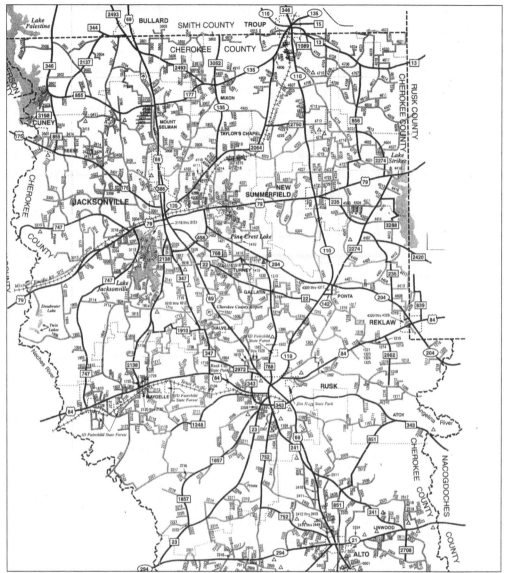

This is a 1955 map of Cherokee County.

IMAGES
of America

CHEROKEE
COUNTY

Cherokee County Historical Commission

ARCADIA
PUBLISHING

Copyright © 2005 by Cherokee County Historical Commission
ISBN 978-1-5316-1635-9

Published by Arcadia Publishing
Charleston, South Carolina

Library of Congress Catalog Card Number: 2005929104

For all general information contact Arcadia Publishing at:
Telephone 843-853-2070
Fax 843-853-0044
E-mail sales@arcadiapublishing.com
For customer service and orders:
Toll-Free 1-888-313-2665

Visit us on the Internet at www.arcadiapublishing.com

CONTENTS

ACKNOWLEDGMENTS

The production of this book has been a labor of love—love of Cherokee County, its people, and its past. The Cherokee County Historical Commission gratefully acknowledges all who helped produce this book, from wishing us well to donating photographs. The primary producers of the book are the current members of the commission and include Ann Chandler, chairman; Terry Guinn, vice-chairman; James Cromwell, secretary; and members Harold Acker; Shelley Cleaver; Inez Conley; Neil Earle; Evelyn Ezell; Ogreta Huttash; Faye Martin; Bernard Mayfield; Suzann McCarty; Elizabeth McCutcheon; Jane Purtle; Mona Roberts; John Ross; Grady Singletary; Kevin Stingley; Mary Taylor; and Mavis Wallace. Special thanks go to the members of the Cherokee County Commissioners Court and county judge Chris Davis.

The majority of the images in this book came from the archives of the Cherokee County Historical Commission. Photographs also came from the Vanishing Texana Museum; the Stella Hill Memorial Library; the archives of the First Methodist Church, Jacksonville; the First Presbyterian Church, Jacksonville; the Texas State Railroad Historical Park; the Cotton Belt Railroad; and the private collections of Marie Whitehead, John Allen Templeton, Jack Moore, Gordon Hugghins, Leonard Hugghins, Tom Dean Stevens, Catherine Chatfield, J. L. Brown, T. E. Acker, Hattie Roach, Sam A. Cobb Jr., Russell E. Fox, Mrs. H. D. Stallings, Lila Cooper, R. L. Faulkner, Freida Lloyd, Mrs. Tillie Young, Mrs. Rosie Coates, Margaret A. Gardiner, Phila Hill Wilson, Mrs. George Anderson, Sam Merrell, Mrs. Douglas Gragard, Mrs. Everett Gragard Jr., Mrs. Bobbie Dowling, Vallie N. Copson, Mrs. R. M. Hoover, Carl Day Bailey, Edgar Brittain, Mrs. Sam Lang, Mary J. Turney, Annie Pearl Lacy, Earla Clifton, C. W. Nichols, Hollis Watson, Webb Finley, Mrs. Lois Henry, Mrs. R. M. Miller, Norma Wagner, Ida Lee Edmiston, J. H. Maloney, Jessie Mae Ruby, C. A. Wilkinson, G. H. Coll, David Loper, and Mrs. Ernest Rountree.

INTRODUCTION

Eureka! We have found it! So might the first white settlers of what is now Cherokee County have shouted when they arrived from the southeastern United States. The area was a veritable paradise, and the pioneers believed they had reached Eden, with abundant wildlife, water, and tillable soil. In addition, the verdant hills reminded them of home, and the views were stunning. The water, wildlife, rich soil, and the views remain today.

Cherokee County, in the central portion of East Texas, is bounded on the west by the Neches River and for 30 miles on the east by the Angelina River. Measuring 50 miles north and south and 30 miles east and west across the middle, the county contains 1,049 square miles of broken terrain. In some sections, the hills approach the size of small mountains, with an elevation of more than 750 feet. One chain, about eight miles east of the Neches River, extends almost the length of the county. East of Mud Creek, a sizable stream flowing across the northeast corner of the county and emptying into the Angelina River, the land is also quite hilly. In contrast, the river bottomland in the southern part of the county descends to an elevation of 250 feet. To the east are spectacular views, culminating at Love's Lookout north of Jacksonville with a view to the east that stretches approximately 35 miles. The climate is typically humid and warm, and the temperature averages about 65 degrees Fahrenheit. Average annual rainfall is 45 inches, occurring mainly in late winter and early spring.

Cherokee County was formed by the Texas Legislature in 1846, one year after statehood, although it had been occupied for decades before that formal act. The county was settled from the south northward, with the first residents being the Caddo Indians, who settled along El Camino Real (now Texas Highway 21) through the Alto area. Soon the Caddos were gone, the victims of pestilence and of immigrant Native Americans driven westward from the United States. These early inhabitants were replaced by both the Cherokee Indians and white settlers from the southeastern United States.

Of course Cherokee County was named for the Cherokee Indians, who had migrated from the eastern United States—first to Missouri, then to Arkansas, and then, in 1819–1820, to Texas. When they asked the Mexican government to give them titles to the land, the Mexicans agreed, but they were not granted clear titles. Within a few years, the Cherokee had grown in number, partly due to intermarriage with the white families who had moved to the area.

Not until the Texas revolution against Mexico began in 1836 did the Cherokees seem like a threat to Sam Houston and several other Texans, who made a treaty with the Cherokees, giving them an area north of the Old San Antonio Road (El Camino Real), bounded by the Neches River on the west and the Angelina River on the east. After the war, the Republic of Texas Congress refused to ratify the treaty and declared it null and void.

Not long after the Republic of Texas was established, the Cherokees became concerned about the titles to their land. A few incidents of violence occurred in East Texas, climaxing with the historic Killough Massacre of 1838 in present Cherokee County, in which the Killough, Williams, and Woods families were slaughtered. Some whites accused the Cherokees of being involved in

that incident, which the Cherokees bitterly denied. Later research proves the innocence of the Cherokees. A band of renegades was responsible.

Nevertheless, the Killough Massacre was the beginning of the end of the Cherokees in Texas. They were defeated in the Battle of the Neches in 1839, a result that effectively destroyed the Cherokee Indian Nation in Texas and opened a large area for settlement by the white man. Cherokee County gained population quickly until 1848, when it, along with two adjacent counties, became one state congressional district.

Cherokee County played a part in politics from the beginning. It is the birthplace of three governors: James Stephen Hogg, the first native-born governor of the state; Thomas Mitchell Campbell, the second Texas-born governor; and John B. Kendrick, who moved from Cherokee County to Wyoming and became governor of that state. The first Cherokee County citizen to sit in the Texas House of Representatives was Benjamin Selman. Over the years, Cherokee County has sent 38 representatives and 9 senators to the state legislature. In addition, William S. Taylor, presiding officer of the Texas House of Representatives at the opening of the 11th Legislature in 1857, was a resident of Cherokee County. Born in Jacksonville, Rayford Price was elected 64th speaker of the House of Representatives on March 28, 1972. Though he grew up in adjacent Anderson County, he returned to Jacksonville to attend Lon Morris College.

Today the southern half of the county remains sparsely populated, in contrast to the northern half. However, the population of the entire county in 2000 was only 46,659. The county seat, Rusk, occupies the center of the county and remains a small, vibrant, downtown-centered town. To the north, Jacksonville is the manufacturing and business center of the county, with nearly 14,000 residents.

The people of Cherokee County are content to live in their own little paradise, with little interference from the rest of the world. There are medical facilities, good schools, plenty of small industry and manufacturing plants, an entire bedding-plant industry, lovely homes, and a lake. Best of all, Cherokee County is home to good, honest, friendly people.

One

GOVERNMENT

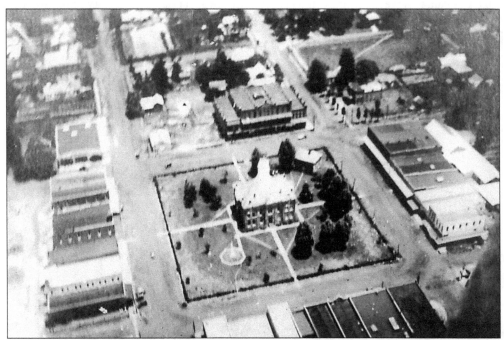

RUSK COURTHOUSE. On April 11, 1846, an act of the Texas Legislature created Cherokee County and called for the site of the county seat to be within three miles of the geographical center of the 50-mile-long county. This legislative act also named the county seat after Thomas Jefferson Rusk, soldier, signer of the Texas Declaration of Independence, and chief justice of the Texas Supreme Court, among other outstanding positions. Lots in the new town of Rusk were set aside for the courthouse, jail, and school. This pre-1920 view of the courthouse in downtown Rusk faces south. In a later remodeling, the entrance was altered to face north.

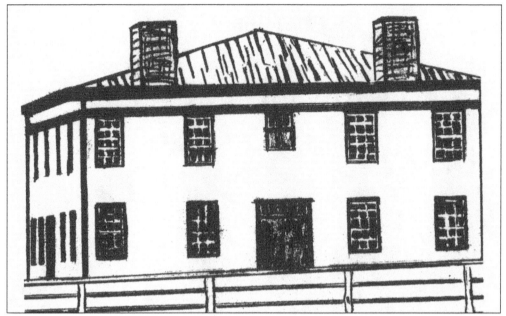

SECOND COUNTY COURTHOUSE. In 1847, a year after the formation of the county, a dogtrot log cabin was built to serve as the first county courthouse. Two years later, the county commissioners let a contract for this two-story frame building, which was condemned and sold in 1888.

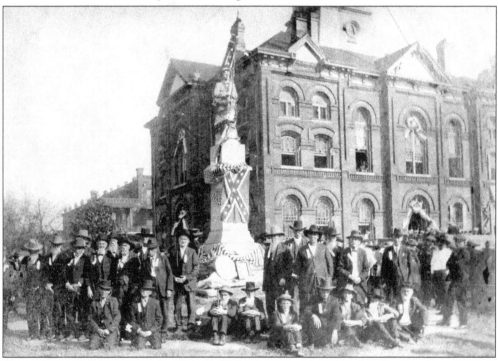

THIRD COUNTY COURTHOUSE. In 1921, Civil War veterans gathered for this photograph opportunity outside the third courthouse building. Flags of both the United States and the Confederacy are draped across the monument on the lawn of the courthouse. The building was used from 1890 until 1926, when an office addition was built on the north side.

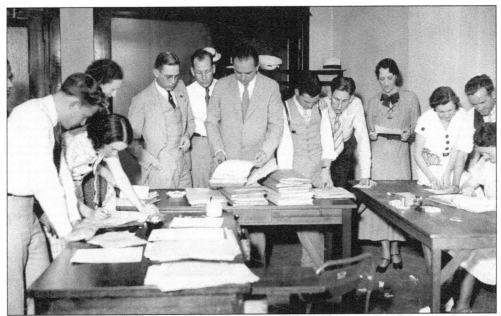

ELECTION NIGHT. On August 19, 1916, this photograph was taken in the basement of the third county courthouse, where Democratic officials and interested parties check election returns. The woman standing to the right of the picture is Lettie I. Baker, the first woman elected to a countywide office in Cherokee County. Baker's election to county treasurer in 1916 occurred two years before she herself could vote in the election.

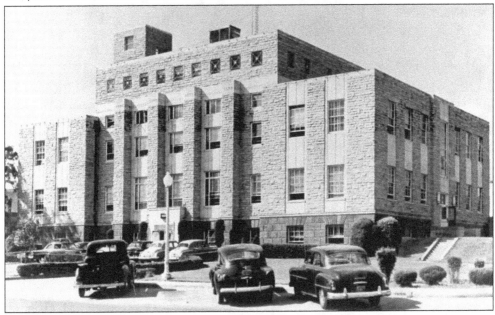

FOURTH COUNTY COURTHOUSE. Cherokee County's fourth courthouse in Rusk is pictured soon after the formal opening held November 11, 1941. This courthouse, still in use today, replaced one built decades earlier that was remodeled several times until it could no longer provide space for all the offices required. All materials used in the construction of this courthouse came from Cherokee County. This building, with the jail on the top floor, faced north.

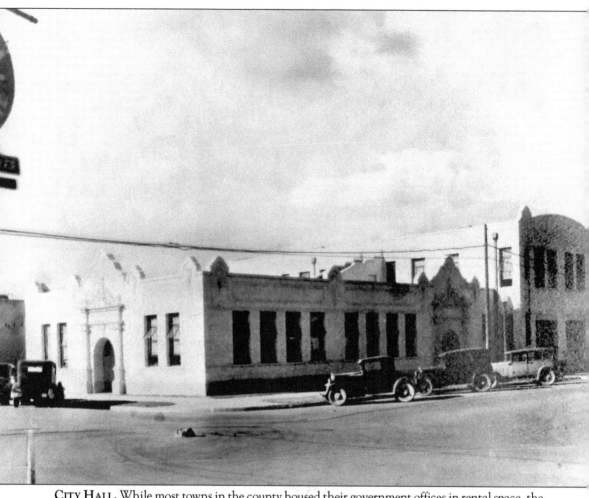

CITY HALL. While most towns in the county housed their government offices in rental space, the City of Jacksonville opened its first city hall at East Rusk and Ragsdale Streets in the late 1920s. All city offices were housed in this building, with the two-story rear section comprising the fire station. The city founders later traded this building for a bank, and the city hall was razed.

Two

EDUCATION

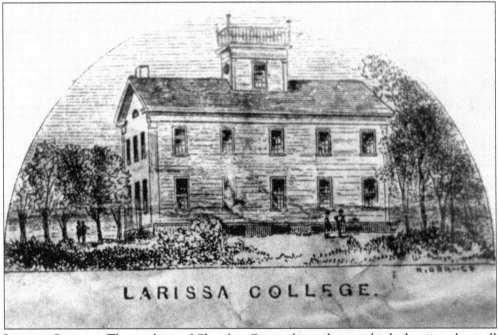

LARISSA COLLEGE. The residents of Cherokee County have always valued education above all else. The county has been home to four colleges, one seminary, numerous common or county school districts, and several private academies. Shown here is Larissa College, which served as the predecessor of today's Trinity University from its inception in 1855 to 1866. Today the county's leafy green campuses vibrate with the learning activities of students from the age of four who are just learning their colors and shapes to those seeking advanced theological degrees.

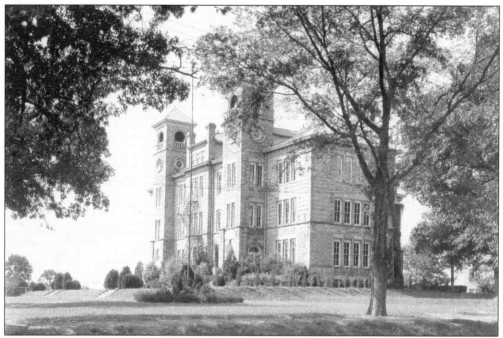

TWIN TOWERS. The main building at Lon Morris College in Jacksonville was erected in 1909 when the college moved to its present site. Constructed of concrete blocks hand-cast onsite, the building had four stories and housed all teaching facilities. Although the Twin Towers became an East Texas landmark as the college grew, it was razed in the 1960s to make room for expansion.

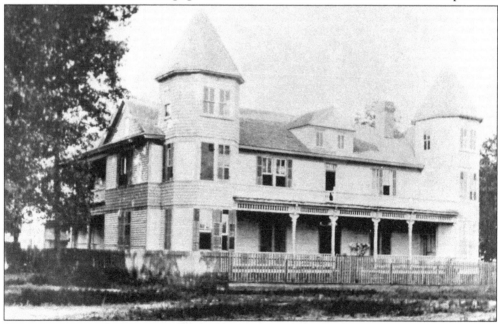

SUNSET ACADEMY DORMITORY. The building housing this girls' dormitory at Sunset Academy in Jacksonville was given to Alexander Collegiate Institute, now Lon Morris College. Note the turrets at each end of the building. When the institute moved to its present location, this area was developed for residential use.

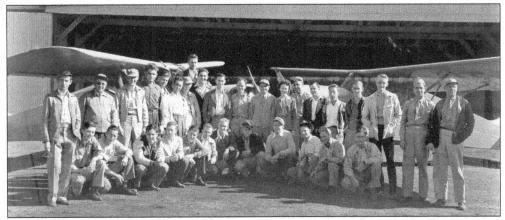

WORLD WAR II FLIGHT TRAINEES. These World War II flight trainees are pictured at the old Jacksonville Municipal Airport off North Bolton Street. Flight training was conducted by the U.S. Navy through Lon Morris College; trainees did class work at the college and were housed in its dormitories while preliminary flight training was conducted from the airport in Taylor Cub planes. The trainees then were sent elsewhere to fly larger aircraft.

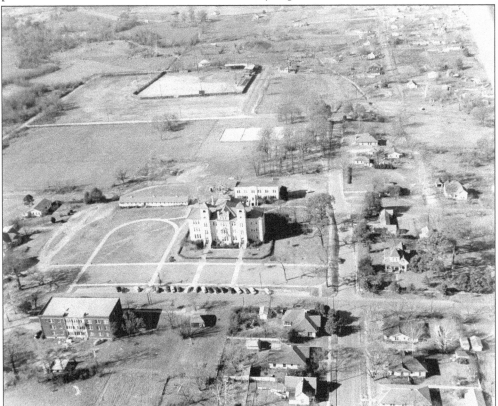

LON MORRIS COLLEGE. In the far background of this *c.* 1946 aerial view is Ragsdale Field, once home of the Jacksonville Jax semipro baseball team. The imposing structure is the Twin Towers, which held classrooms and administration. Directly behind it is a dormitory. Science classes were held in the long, low building to the left. Across College Avenue (where cars are parked) is Lula Morris Hall, another dormitory. The Twin Towers faced east.

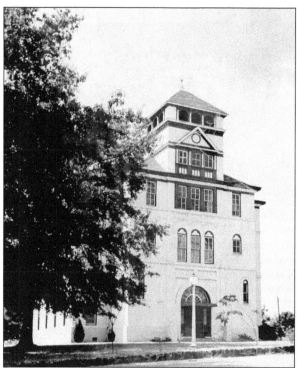

OLD MAIN. Jacksonville College's first building, called Old Main, opened in 1900, one year after the establishment of the college, and served as its only structure for several years. It was razed and replaced with the present academic-administration center. The Old Main's tower housed a huge bell rung for the beginning and close of classes each day and later, for celebrating Jacksonville Jaguar basketball game victories.

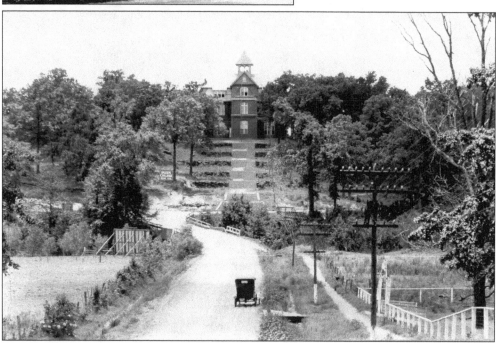

RUSK COLLEGE. Rusk College experienced many ups and downs during its existence from 1895 until 1928. At times, Baptists and Methodists operated the college, but its financial situation was always precarious. This administration building on South Main Street sat atop seven tiered terraces and steps, the centerpiece of an ideal location for the college. As automobiles became more numerous, salesmen would drive their demonstrator models up the steps to show their power.

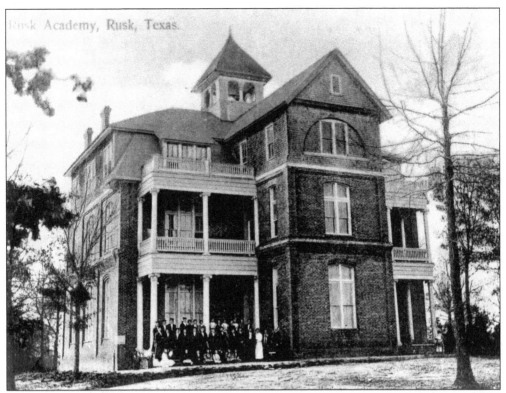

Rusk Academy, Rusk, Texas.

RUSK ACADEMY. This undated postal card sold by Moseley Drug Store in Rusk shows one of the early schools operated in the town before the public school system was established. The academy was of substantial nature, judging from the quality of the building, and had a large enrollment, as evidenced by the number of students pictured.

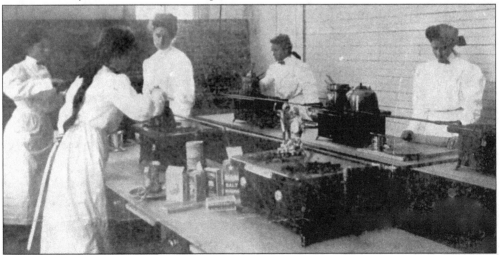

DOMESTIC SCIENCE CLASS. Students in a domestic science class in Rusk's Academy of Industrial Arts for Girls are learning to cook. As the school sought to build enrollment, the school's president, J. W. Wright, explained in the catalog that "Your daughter may receive a first-class Academic Literary Education, also Domestic Science and Domestic Art Training, board included, for $125.00 for nine months. Music, art, education, and Physical Culture extra."

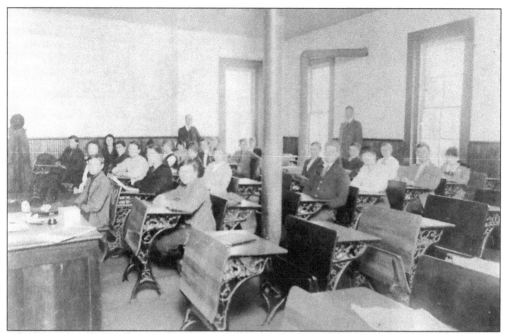

ALTO SCHOOL. This photograph shows the interior of a room in the Alto Public School in 1915 when C. A. Wilkinson was principal and teacher. The man on the left is probably Ernest L. Oliver, superintendent of schools at the time. The others are unidentified.

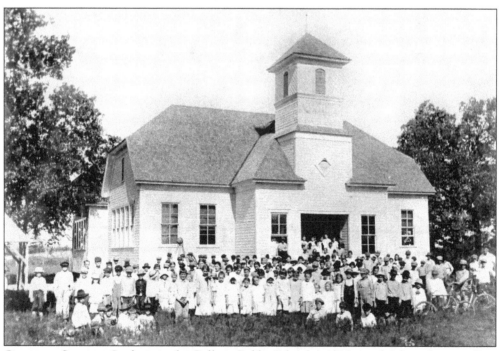

GALLATIN SCHOOL. Students in the Gallatin Public School in 1916 pose for their photograph in front of the building, which was later replaced with a more modern structure.

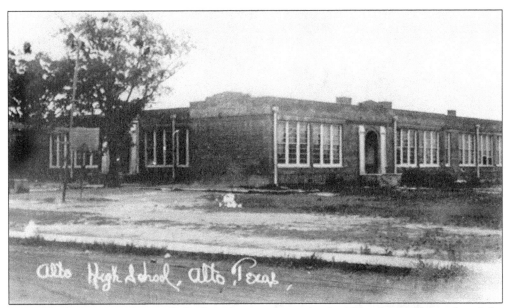

ALTO HIGH SCHOOL. Originally built with two stories, this building was condemned and the second story was removed about 1929. Due to the Depression, however, the school was used for several more years.

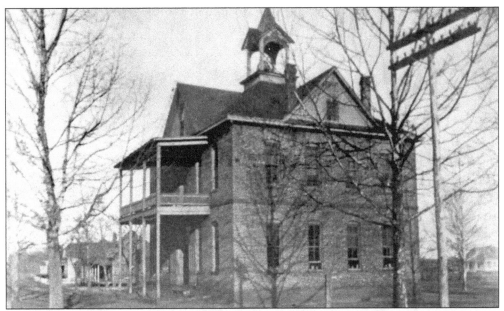

FIRST BRICK SCHOOL BUILDING. The first brick school building in Jacksonville was built about 1910 on the corner of Austin and Rusk Streets to house all grades. The building had only five rooms. When the student numbers became too great, small buildings across the street were utilized to accommodate them. A new, large high school was built on Tomato Bowl Hill in 1913.

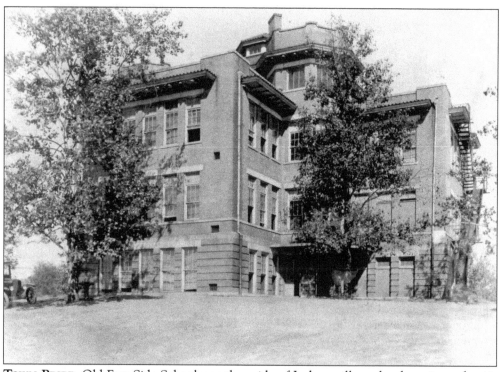

TOWN PRIDE. Old East Side School was the pride of Jacksonville and a showpiece when it opened in 1913 on the present site of Tomato Bowl Stadium, also the site of the town's first free, public school. The school replaced an earlier one at Austin and Rusk Streets. It was designed as a high school, but some elementary students were housed in it at first. Later it officially became an elementary school.

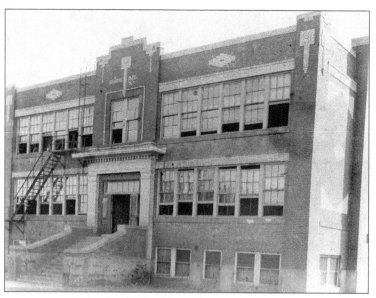

HIGH SCHOOL. Jacksonville's next high school, later Joe Wright Elementary on Kickapoo Street, was built in 1915 after the old school on Tomato Bowl Hill became too crowded. The property owner refused to sell the site unless the school was named for her late husband. It became an elementary school in 1926 when yet another high school was built on Neches Street.

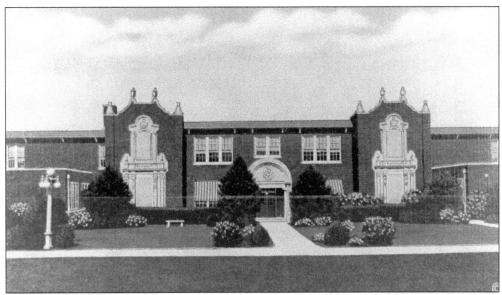

NEW HIGH SCHOOL. Jacksonville's fourth high school opened in 1926 on Neches Street and was used until a newer one was opened in 1957 on Mason Drive in southeast Jacksonville. This building became the Jacksonville junior high school after 1957 and was razed in 1980, when newer middle-school buildings were opened on Pine Street. The previous high school became Joe Wright Elementary on Kickapoo Street when the above building opened.

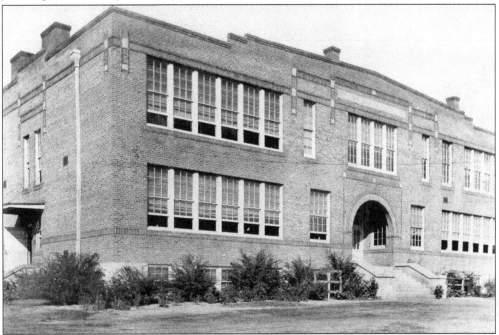

WEST SIDE SCHOOL. To meet the fast-growing need for school facilities in Jacksonville, the West Side Elementary School on Hickory Street was opened in 1922. It was not furnished completely for several years, and plain wooden benches were used for seating in the auditorium. The school was so crowded that grades were doubled in the same room with half of the students being taught at a time while the other half studied.

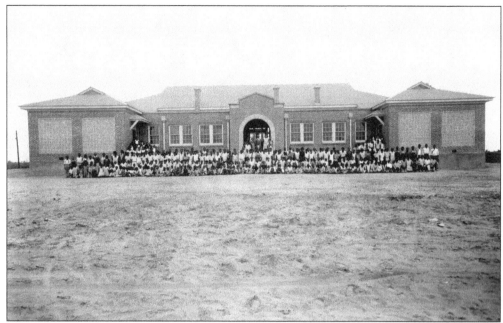

FRED DOUGLASS SCHOOL. African American students and faculty of Fred Douglass High School in Jacksonville's pre-integration days pose for their photograph at the school entrance about 1930. The building, constructed in 1922, was funded in part by a grant from the Rosenwald Foundation. After integration, the building was used for special education classes until it burned in the 1980s.

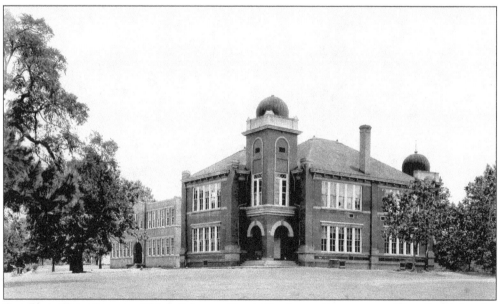

OLD RUSK HIGH SCHOOL. This building on North Henderson Street was used for several decades before being replaced with a new one on South Henderson Street near the First Methodist Church. This is the site of an elementary school built after this one was no longer used. Note the tower-style entrance in the foreground and the dome of a similar one at the entrance on the other side of the building.

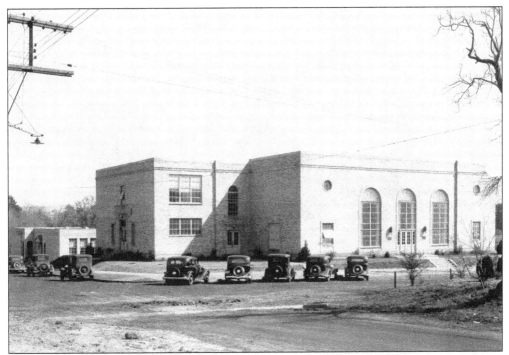

SECOND RUSK HIGH SCHOOL. This high school was built on South Henderson Street in the 1930s to accommodate a larger enrollment of students than the earlier building on North Henderson Street. This building served the Rusk system until the present high school was built on Salem Road. The old high school plant later became a community center and the site of a private Christian school.

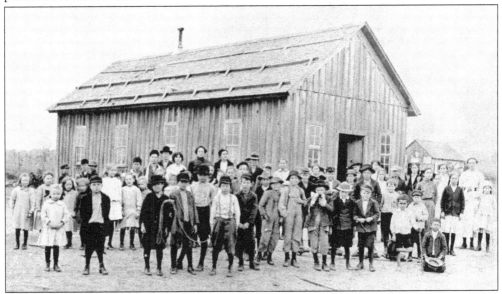

MAYDELLE SCHOOL. Around 1912, classes for the Town of Maydelle's first school were conducted in an old store. Maydelle continued to operate a public school system until the late 1980s, when it was consolidated with the Rusk Independent School District after the community could no longer support a school system. The students and faculty in this photograph are unidentified.

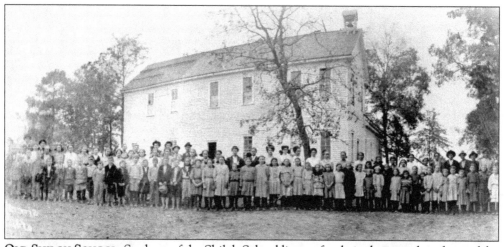

OLD SHILOH SCHOOL. Students of the Shiloh School line up for their photograph in front of the building, *c.* 1910. Note the typical school bell in the belfry atop the two-story structure. After the school was consolidated with the nearby Turney school, the structure was remodeled for use as a residence and the top story removed. Former students still convene annually for a reunion.

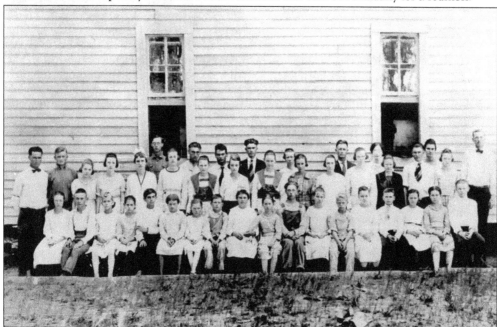

SINGING SCHOOL. Popular in earlier days were annual singing schools conducted by traveling singing masters to teach people how to read music. This one was held in the Union Grove church in the late 1930s. From left to right are the following: (first row) Fannie Dover (organist), Richard Griggs, Myrtle Edmiston, Verda Davis, Cecil Griggs, Lillian Lloyd, Mina Mae Edmiston, Noel Pierce, Monnie Archer, Irene Taylor, Foster Grisham, Georgia Gay, Leighton Grisham, Ruby Archer, Oliver Bridges, Opal Lloyd, Ruby Taylor, and Mart Hill; (second row): John Gregory (teacher), Charlie Edmiston, Thelma Pryor, Annie Reynolds, Mattie Pierce, Letha Davis, Flaura Williams, Freddie Gay, Macie Williams, Eva Gay, Minnie Arnold, Ruby Nolley, Mollie Hill, Floyd Sides, Edith Morehead, and Hershel Reynolds; (third row) Alfred Edmiston, Bruce Griggs, Roy Dover, Bernice Yancey, Nellie Reynolds, Pearl Edmiston, Cora Roycroft, and Maudie Lloyd.

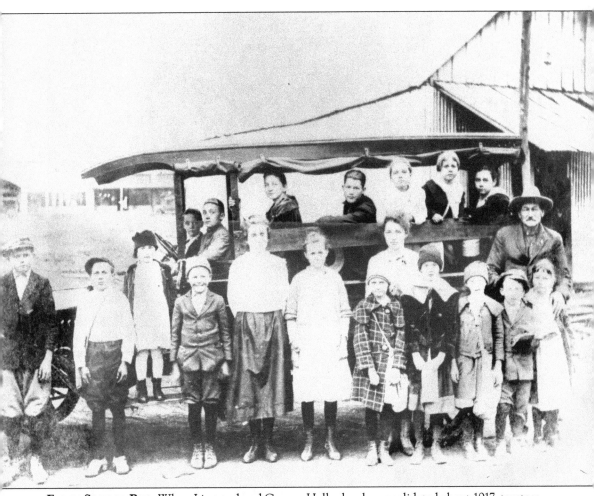

EARLY SCHOOL BUS. When Linwood and Grange Hall schools consolidated about 1917, trustees agreed that transportation would be provided for the students, but the free service via wagon only lasted one year. Parents of the students then bought a Ford truck chassis and built a bed on it to carry the children to school in Alto.

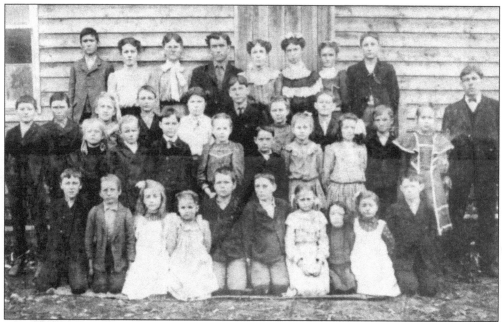

MUD CREEK SCHOOL. Students of this common school district on Mud Creek in the eastern part of the county posed for this photograph in the early 1900s. The only student identified is Marvin Troublefield (third row, fourth from left).

Reese School. These students of the Reese Common School pose during the 1920s. From left to right are (first row) Bruce Strickland, Gladys Douglas, Adeline Evans, Lena Etheridge, Curtis Collins, Luther Collins, and Miss Rose Lee Thomas (teacher); (second row) Manley Smith, unidentified, George Clark, Bill Dalton, Dick Collins, Lewis Larson, Woodrow Temple, Dick Dalton, and Gwendolyn Larson.

Three

STRUCTURES

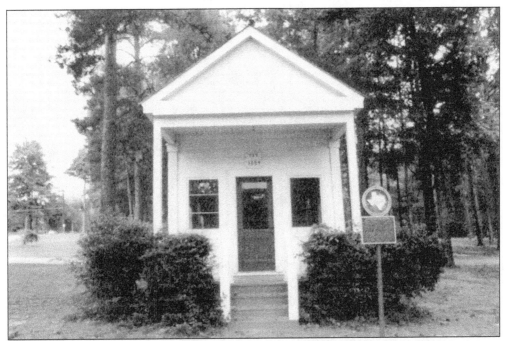

BONNER BANK BUILDING. Built in 1865, the oldest financial institution in Rusk is now a museum on Highway 69 South. A home, plain or fancy; a monument; even a footbridge—structures provide the history of a county even after the images are gone. Whether a barn, a residence, a business, or a memorial, these buildings remind us of what Cherokee County once looked like and how we lived.

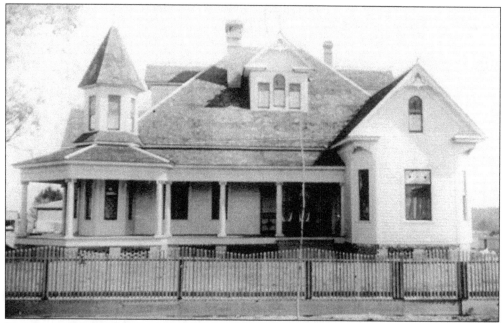

BERRYMAN HOME. This Victorian home in Alto was the home of the Berryman family around the beginning of the 1900s. The house was located on the corner of Berryman and Mill Streets, with the entrance facing Mill Street, as shown in this view.

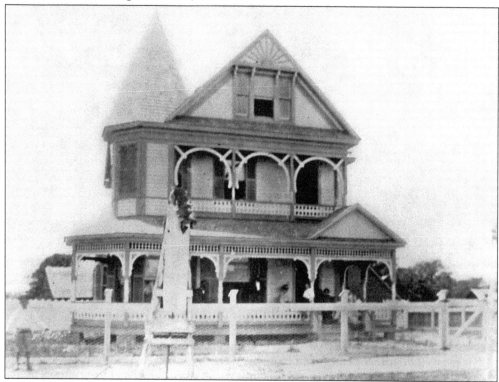

SORY HOME. This house in Jacksonville, photographed in 1899, was home to local grocer Samuel Houston Sory and his family.

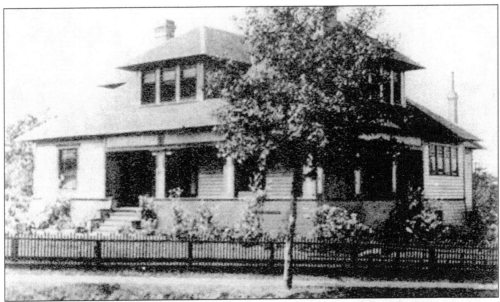

FRANCIS HOME. The residence of Dr. and Mrs. C. C. Francis at Shiloh Road and Singletary Street in Alto, photographed in 1910, shows the influence of the Prairie Style school of architecture, which followed the Victorian style. Dr. Francis was physician for the Blount and Decker Lumber Company.

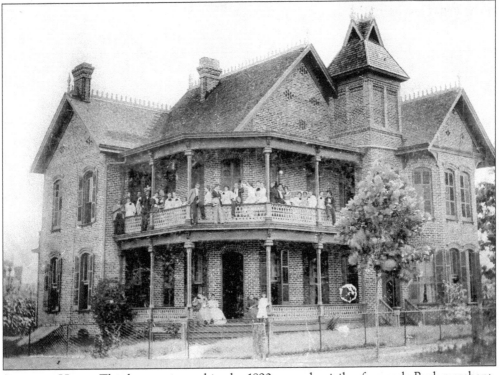

SUMMERS HOME. This home, pictured in the 1890s, was domicile of an early Rusk merchant. The home still stands today on the corner of Fifth and Sycamore Streets, although in a slightly changed form.

HOLSOMBACK HOME. This home was built in the 1920s for a merchant in the town of Maydelle. Typical of the time, the large wraparound porch on this farm-type home was intended to catch summer breezes.

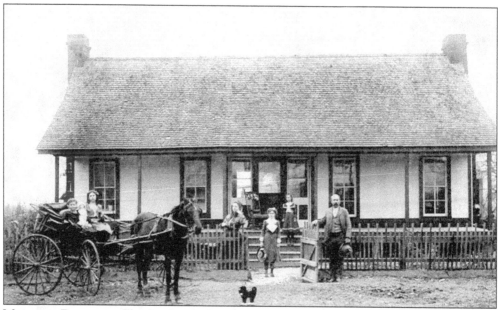

MODIFIED DOGTROT. The family who lived in this home is unidentified, but the style of the dwelling is typical of the late 1890s through the 1920s. A door has been installed at each end of the dogtrot. The house would have been oriented north and south to catch summer breezes. Note the chimneys, the toys, and the clean-swept front yard.

FRANCIS HOME. This home in the 500 block of South Bolton Street in Jacksonville was built around 1900 in the Victorian, two-story style with a wraparound porch on the ground floor and a shorter gallery on the second, complete with gingerbread trim. This photograph was taken in 1983.

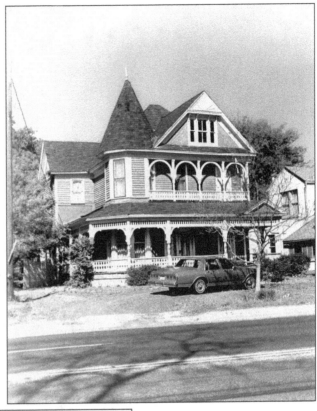

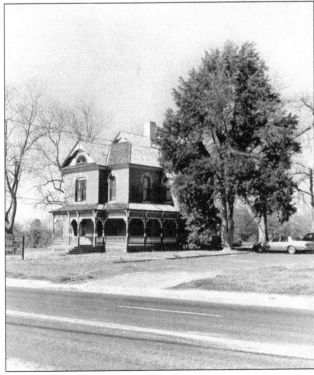

HABERLE HOME. This brick, two-story Victorian house at 833 South Bolton Street in Jacksonville, shown here in 1983, was built between 1891 and 1896. The bricks were manufactured at the Haberle-Aber Brick Factory. Later Mr. Haberle turned to the manufacture of baskets for the peach and tomato industry.

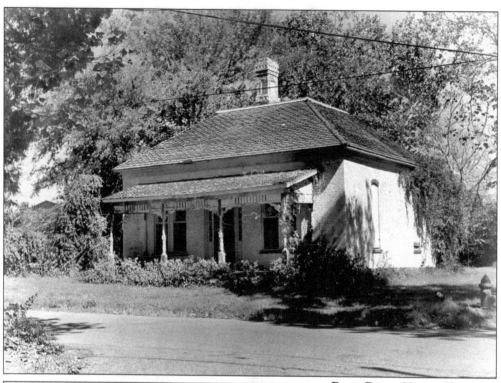

FIRST BRICK HOME. This house, located on the corner of Bonner and Devereax Street in Jacksonville, was built around 1890 for the mother of Edgar Aber. The bricks were fired at the Haberle-Aber Brick Factory, which stood nearby. The derelict house, shown here in 1983, was torn down by the city in the early 2000s.

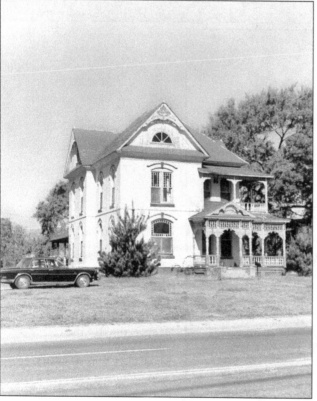

ABER HOME. The home of the Ed Aber family was built in the 1890s on South Bolton Street, directly in front of the Haberle-Aber Brick Factory. Mr. Aber was the next-door neighbor and business partner of his relative, George Haberle. Together the men participated in the tomato industry, as well as brick making and construction.

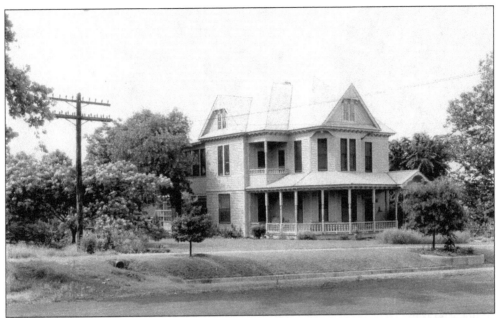

BROWN HOME. The home of Mr. and Mrs. J. L. Brown on West Rusk Street, Jacksonville, was typical of the fine homes in the town in the late 1880s and 1890s. Mr. Brown was an early merchant. The home was moved to the community of Ironton in the 1970s and is still a residence, although not in its original condition.

W. A. BROWN HOME. This home on Patton Court in Jacksonville is now known as the Larissa House Restaurant and Emporium. It was built in 1858, 14 years before the town moved to its present location. It is believed to be the oldest existing home in Jacksonville and is listed on the Texas Historical Landmark register.

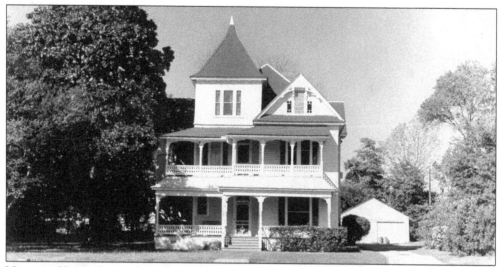

NEWTON HOME. Located in the 500 block of South Bolton Street in Jacksonville, the Newton home was built in 1899. Its Victorian style is reflected by the verticality of the house, the porches, and the millwork. It is still occupied and looks very much as it did in 1983, when this picture was taken.

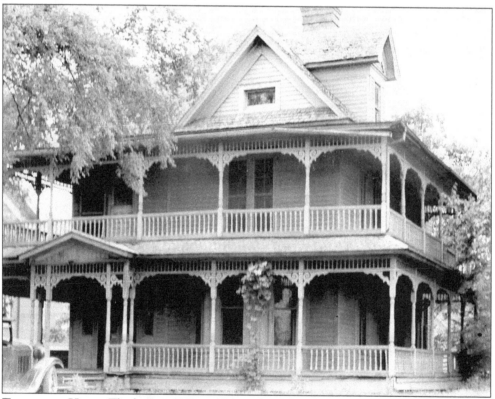

TEMPLETON HOME. The home of Mr. and Mrs. John Allen Templeton I on South Main Street was one of several Victorians built in Jacksonville in the 1880s. It featured a giant central chimney arrangement and its own running water system with bathrooms on each floor. The kitchen and cook's home were in a separate building a short distance from the house.

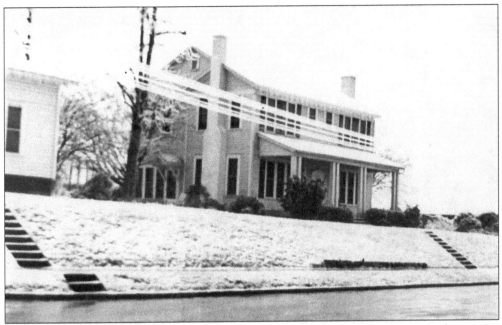

FULLER HOME. The home of Dr. and Mrs. John B. Fuller in Jacksonville was built in 1872. Dr. Fuller was the patriarch of a long line of physicians who served Jacksonville, most of whom lived here at one time or another. The house was remodeled into the two-story structure shown in this 1936 photograph. It no longer exists.

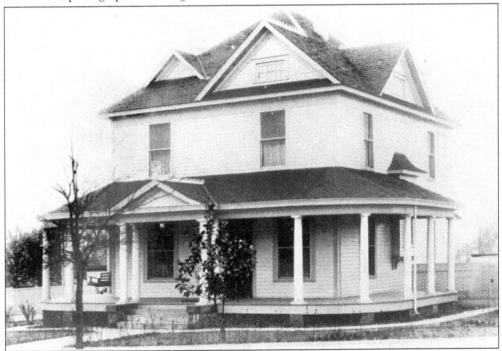

TURNER HOME. Located on Nacogdoches Street in Jacksonville, the home of early businessman P. D. Turner is still occupied today. Built in 1911, it had the wraparound porch but none of the fancy millwork common to most Victorians.

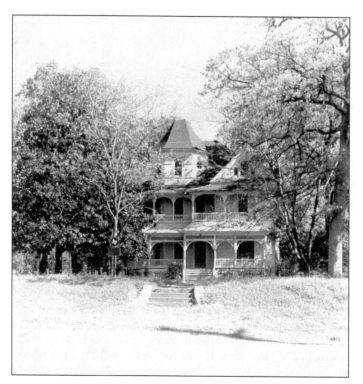

WESLEY LOVE HOME.
Located on Love Street in
Jacksonville, this beautiful
Victorian was built around
1881. Mr. Love was a
pioneer peach orchard
man and partner in several
businesses in the area.
The home is currently
used as offices and is in
exceptional condition.

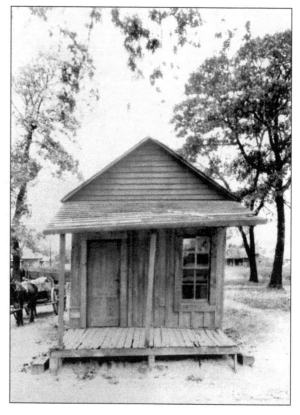

SHOTGUN HOUSE. Typical of low-
rent housing for servants and low-
income citizens was this "shotgun"
house. The term came from the fact
that these houses had only a front
and back door and all rooms from
front to back opened into each other
without a hallway. Supposedly, one
could fire a shotgun through the
front door and the bullets would
go straight out the back door.

RESTORED BARN. Originally built around 1920, this barn was faithfully restored in the Corine community west of Jacksonville, down to the cedar shake roof.

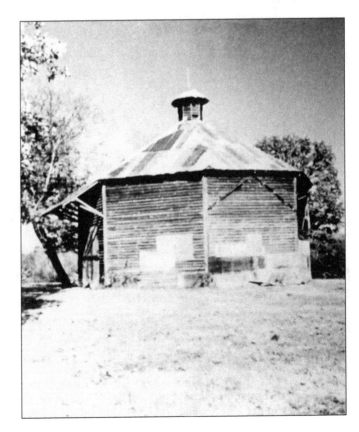

OCTAGONAL BARN. This rare, eight-sided barn on the farm of Reba Sessions in New Summerfield is the only one of its type known in Cherokee County. Built around 1900, it is still in use. There is no interior support for the structure, adding to its rarity.

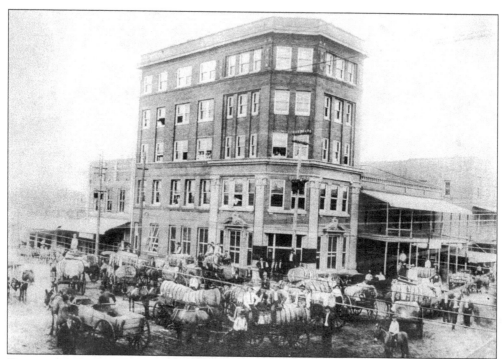

TALLEST BUILDING. For many years, the tallest building between Shreveport and Dallas was the five-story First National Bank in Jacksonville, shown here during cotton market before 1900. The top three stories were removed in the early 1960s, and the resulting two-story building is still in use.

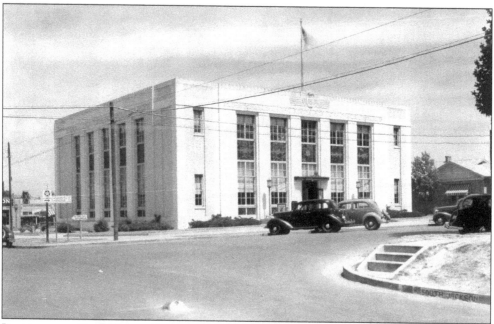

JACKSONVILLE POST OFFICE. Built in 1933, this 1937 image shows the post office much as it looks today as Stamps Restaurant (downstairs) and the Landmark Hotel (upstairs). The building is on the National Register of Historic Places and is located at the intersection of Highways 69 and 79.

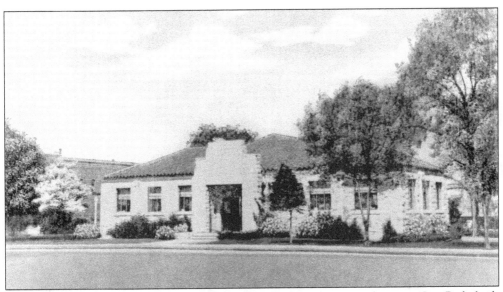

LIBRARY'S FIRST HOME. Jacksonville Public Library's first permanent home in City Park, built in 1941 as a Works Progress Administration project, was used until the new library facility was opened on South Jackson Street in 1984. This building now houses the Jacksonville Senior Citizens Center.

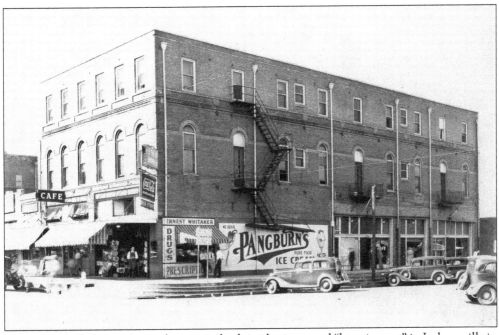

WHITAKER'S CORNER. A popular corner for doing business and "hanging out" in Jacksonville in the 1930s to 1960s was the Ernest Whitaker Drug Store and the Etex Café just north, with the Etex Hotel on the upper stories of the building. Several other businesses occupied this corner of Rusk and Main Streets until the entire property was leveled by fire in 1980.

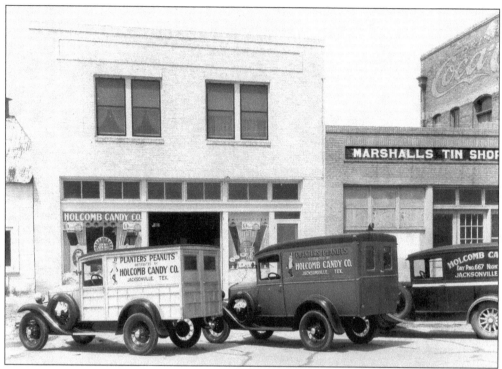

HOLCOMB CANDY COMPANY. Later known as Jacksonville Candy Company and still operated by the Holcomb family, this business was located on East Rusk Street in the 1930s and became one of Jacksonville's most successful businesses. The firm eventually moved to East Woodrow Street, its current site.

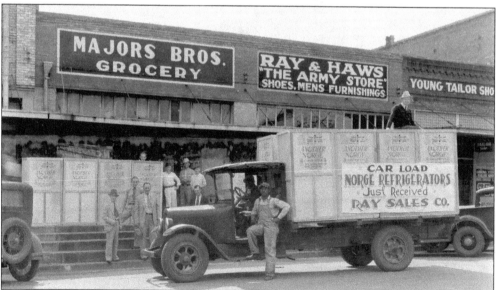

RAY SALES COMPANY. Located on South Main in Jacksonville, Ray Sales held the Norge dealership in the 1930s and 1940s. Those identified in the photograph are Arlon Wiggins (on steps with hat in hand), A. S. Hall (in dark suit), and Jim Swink (atop the truck). Note the sign for Young Tailor Shop. That business remained in the same location until 1988.

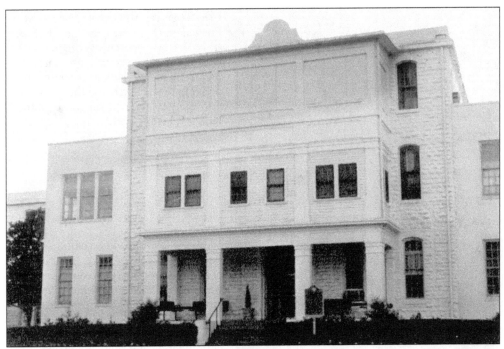

RUSK STATE HOSPITAL MAIN BUILDING. Constructed in the mid-1800s, first as Rusk State Prison, then as a mental care facility, the Rusk State Hospital was greatly reduced in size with the advent of community-based care and the concept of "least restrictive environment" for mental patients. The adjacent property once again houses state prisons—two of them.

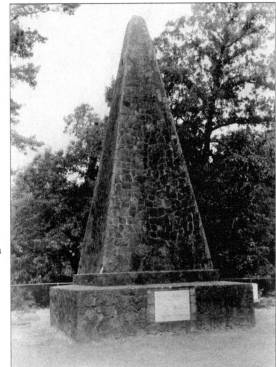

KILLOUGH MONUMENT. The monument in northwest Cherokee, erected in the 1930s as a Works Progress Administration project, commemorates the massacre of the Killough, Williams, and Woods families in 1836 by a band of renegades, thought for decades to have been Cherokee Indians. Later research cleared the Cherokees, but not before they were defeated by the Republic of Texas Army and banished to Oklahoma in 1839.

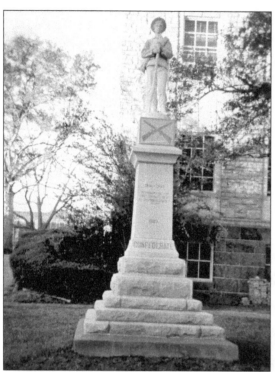

CONFEDERATE VETERANS MEMORIAL.
Erected on the courthouse lawn in Rusk
in 1907, the memorial was originally
at the front of the courthouse. Later
remodeling and rebuilding oriented the
building to the north and the statue
now occupies the rear left corner of the
building, facing south.

WORLD'S LONGEST FOOTBRIDGE.
Built in 1861 so that residents east
of Rusk could get to town during
wet weather, this bridge was 546 feet
long, four feet wide, and spanned a
deep ravine. The bridge was rebuilt in
1889 and again in 1960. The women's
clothing indicates that photograph
was taken sometime in the 1800s.

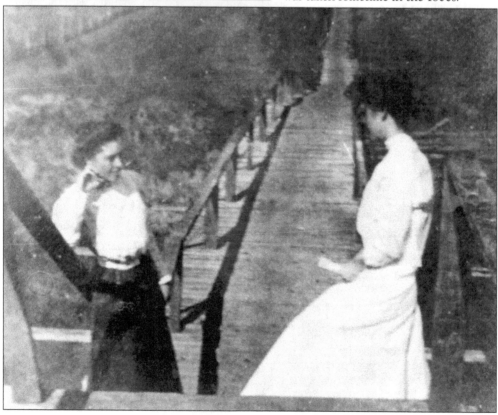

Four

DOWNTOWN SCENES AND BUSINESSES

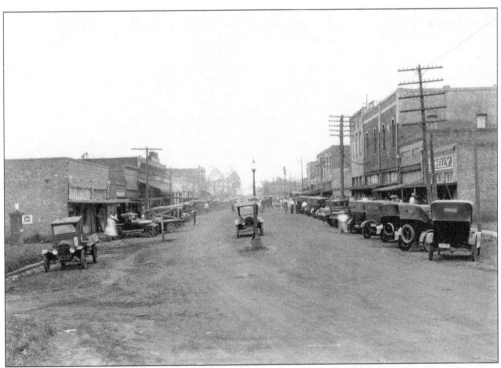

ALTO BUSINESS DISTRICT. Perhaps no part of a town changes so much as its downtown business district. Only when these buildings and their businesses are gone do the residents feel their loss and wax nostalgic for what is no more. This image is of the Alto business district looking east in the 1920s. Note the streetlamp in the center of the street and the large number of Ford vehicles.

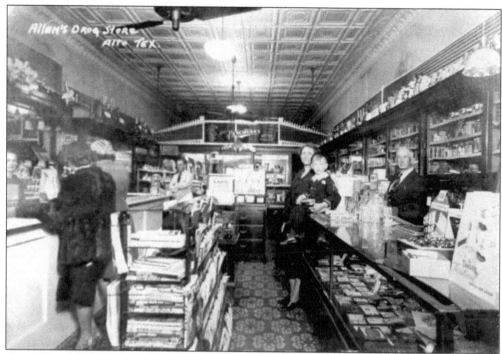

ALTO DRUG STORE. The Allen Drug Store was a busy place in 1949 when it was owned and operated by Oscar Allen. Shown here, from left to right, are Miss Ida Lee Durrett (behind counter), two unidentified customers, an unidentified employee (end of counter), Mrs. Coy Maye Allen, John Ellis Allen, and Oscar Allen.

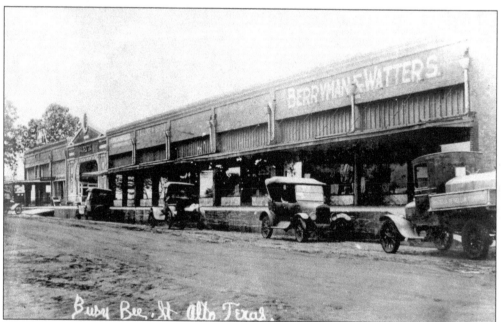

EARLY ALTO. This 1924 scene shows the Ford automobile dealership to the far left, the post office, the ornate Majestic Theater, and the Berryman and Watters Dry Goods Store, which took up most of the block.

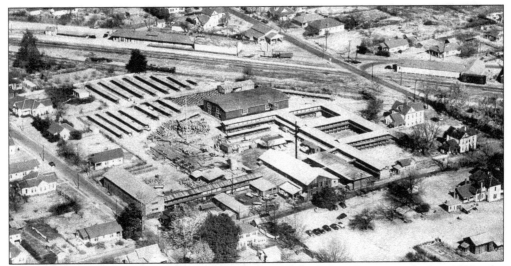

ABER BOX FACTORY. In this aerial view of the Aber-Haberle Box Factory in the late 1930s, the diagonal street in the upper right is South Bolton Street. The railroad track and depot belonged to the Texas & New Orleans Railroad, later Southern Pacific. The two large houses on the right in front of the box factory are the Aber and Haberle homes, still located on a now-widened South Bolton Street.

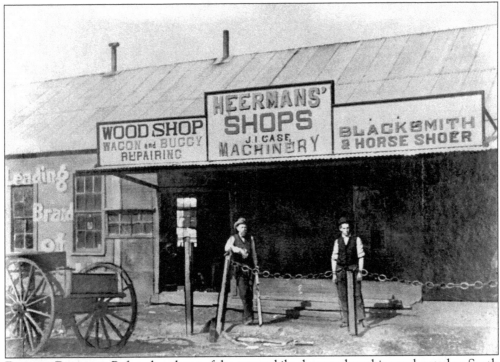

DOOMED BUSINESS. Before the advent of the automobile, shops such as this one, located on South Bolton and Rusk Streets in Jacksonville, took care of the needs of horses, buggies, and wagons. The man on the left is John Addison Heermans (owner). The worker is unidentified.

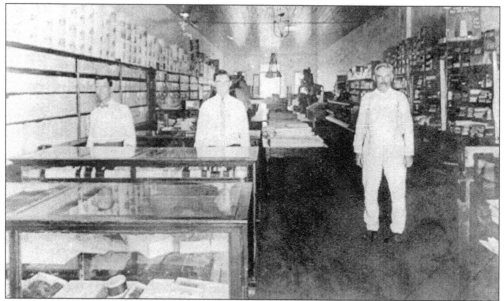

ARRANT'S STORE. In 1915, Arrant's Store, a purveyor of general merchandise, was located on the south side of San Antonio Street in Alto. Although the gentlemen in the photograph are unidentified, one is probably owner R. E. Arrant.

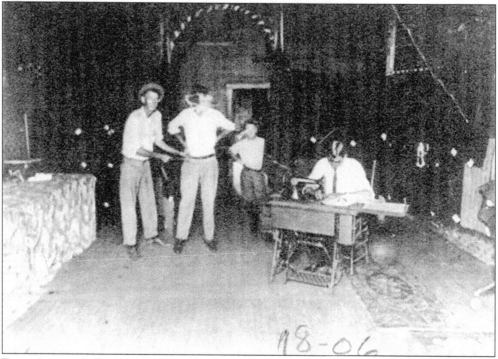

FRED CROUCH'S TAILOR SHOP. This undated photograph shows Arch Holcomb measuring Mallie Houston, with an unidentified young man in the rear, and Fred Crouch at the sewing machine. Before stores carried "off the rack" clothing, tailor shops filled the need. Later, tailor shops would transform themselves into dry cleaning establishments, with the tailoring taking the form of alterations only.

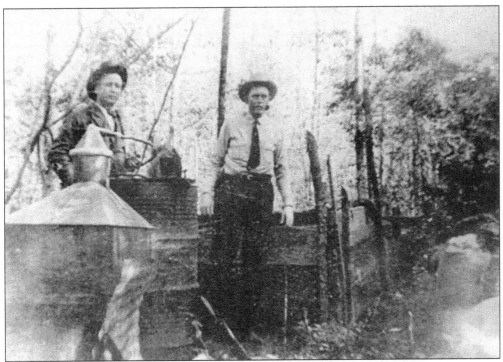

SHUTTING DOWN THE LAST STILL. Sheriff Frank Brunt and Deputy Homer Spears close down the last big still in Cherokee County in 1950. Homemade whiskey was for many years one of the most successful businesses in the Alto (Dogtown) area, and the whiskey made here was known all over East and South Texas. The location of this illegal still was some eight miles from Alto.

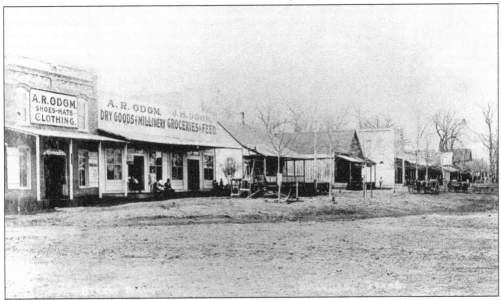

DIALVILLE SCENE. Dialville's business district, shown here in the winter of 1910–1911, when the old town was more in its heyday, reveals several businesses and citizens. The advent of better roads to Jacksonville and Rusk lured business away from the town and led to its eventual demise as a popular trade center for that area of the county.

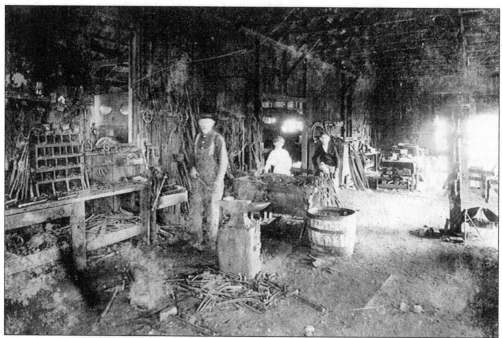

BLACKSMITH SHOP. This 1900 photograph shows Baylis Grace Acker in his blacksmith shop in Dialville. The two boys are unidentified.

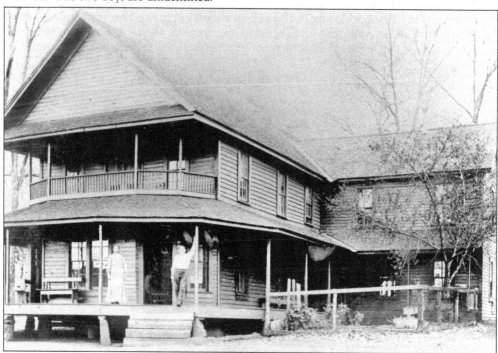

DIAL HOUSE. This Dialville hotel was established by John J. Dial, Civil War veteran and developer of the town that sprang up when the Kansas & Gulf Short Line Railroad (later Cotton Belt) was built through the county from Tyler to Lufkin. Dial later leased the hotel to various operators. Mr. and Mrs. J. T. Bailey were the hotel's operators when this 1908 photograph was taken.

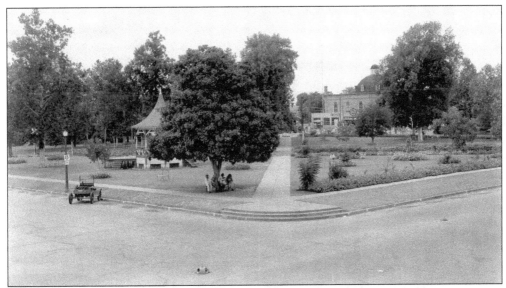

CITY PARK. City Park in Jacksonville, viewed from South Main and East Rusk Streets, was given to the town in 1872 when the International & Great Northern Railroad laid out the town. The bandstand became the site for public meetings and entertainments. In the background is the earlier First Methodist Church. Note the stop-sign buttons in the center of the streets in this photograph taken around 1926.

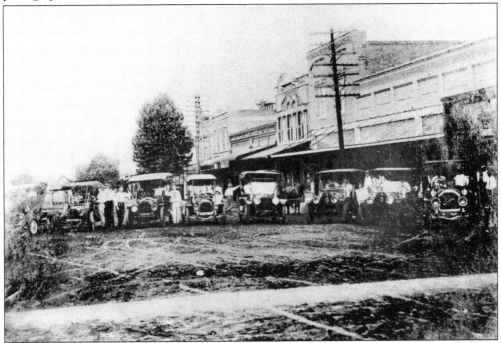

AUTO DISPLAY. Early Jacksonville residents display their automobiles in the 100 block of East Commerce Street, *c.* 1914. Note that some are right-hand-drive models and all had the "buggy style" tops. Stores in the background include Ragsdale Brothers, J. L. Brown Department Store, Brown and Dixon, Gragard Brothers Hardware, and John H. Bolton Drug Store. All have disappeared from the Jacksonville business scene.

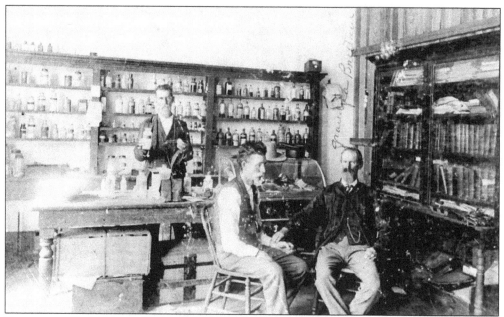

DOCTORING. Dr. J. M. Brittain, an early doctor in Jacksonville (right), examines an unidentified patient in his office by taking his pulse. Dr. Brittain and a brother, Dr. J. B. Brittain, came to Jacksonville in the 1880s after first practicing medicine in northeast Cherokee County. Dr. J. M. Brittain remained in Jacksonville while his brother moved on to West Texas to practice medicine.

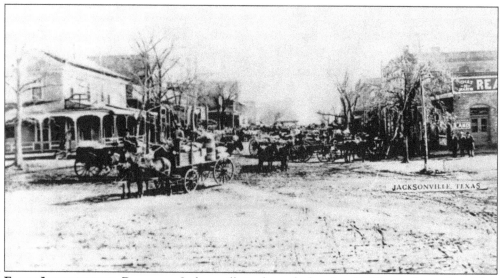

EARLY JACKSONVILLE. Downtown Jacksonville in the early days (pre-1900) was a busy place. This view looks south from the International & Great Northern Railroad station with the Heidelberg Hotel in the left foreground. Note the well in the center of the intersection of South Main and East Commerce Streets. Although the well was filled in a few years later, it was an important facility provided by the town for watering horses and mules in pre-automotive times.

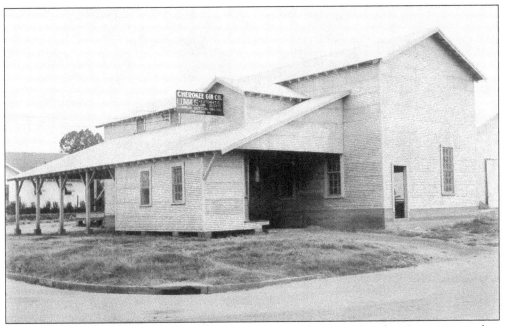

CHEROKEE GIN COMPANY. The first fully electric-powered gin in Cherokee County opened in Jacksonville in the late 1920s or early 1930s. This gin was one of several located on the same site and replaced one that had burned. Jacksonville had three cotton gins operating at the same time in the days when cotton was the principal cash crop in Cherokee County. This was the last one to shut down.

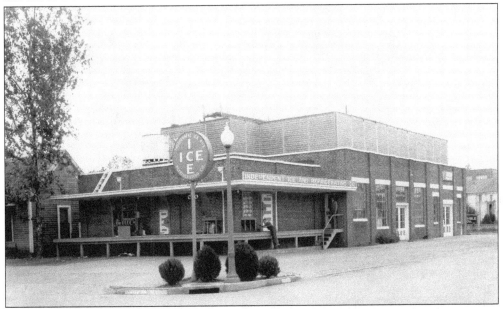

ICE HOUSE. The Independent Ice and Refrigerating Company at Rusk and South Jackson Streets was opened in the mid-1930s by B. H. Giles and operated until the late 1940s. The firm sold ice and provided commercial refrigeration services. At the far right corner of the building is Mack's Dairy operated by Mr. and Mrs. H. P. McClendon as a wholesale and retail business. The men in this 1940 photograph are unidentified.

CHESSHER HOTEL. Melvina Chessher stands in front of her home, the former Chessher Hotel, Jacksonville's first, which was located on East Rusk Street. Mrs. Chessher lost her husband in the Civil War and operated the hotel to support herself and her children. Mrs. Chessher lived to be 106 and had her 100th birthday proclaimed as Mrs. Chessher Day.

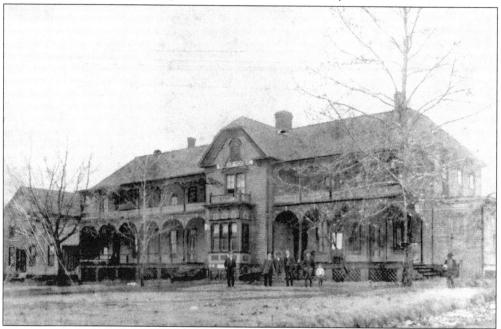

SPEAR HOUSE. Jacksonville's second hotel opened soon after the town was laid out and not long after Mrs. Chessher closed her hotel. The Spear House was a leading regional hotel for many years, the scene of all major social and community events. It was replaced by the Pearl Hotel, which burned in the early 1920s and was in turn replaced by the Liberty Hotel.

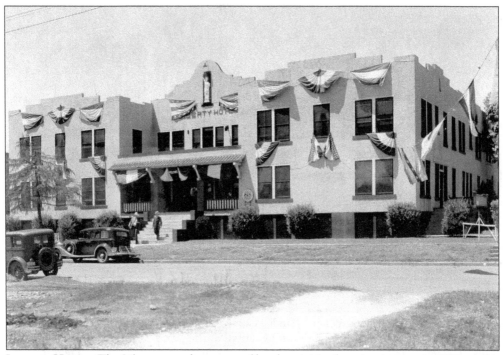

LIBERTY HOTEL. The Liberty was the center of local activities from its opening in 1920 until it burned in 1972. The hotel drew its name from the fact that local citizens converted their World War I Liberty Bonds into cash to purchase stock to finance the hotel. The hotel was headquarters for tomato shippers and buyers during the busy days of the Jacksonville tomato season.

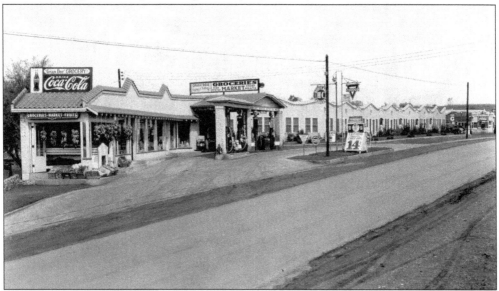

GRAN-DEE COMPLEX. Jacksonville moved into a more modern travel era with the opening of the Gran-Dee Tourist Courts at North Bolton and Frankston Streets in the mid-1930s. The complex included the service station at the south end, tourist housing in the center, and a restaurant at the north end. The complex was eventually razed, but was a popular late-night hangout from its inception through the 1960s.

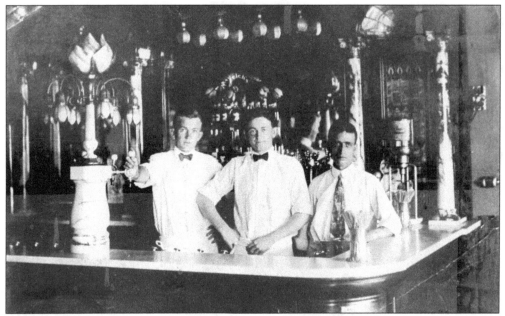

BANDO'S. C.C. Bando (right) operated Bando's Candy Kitchen confectionary in Jacksonville on South Main Street in the early 1900s until he retired in the 1930s. Posing with Bando are two of his "soda jerks." Bando's was famous for its ice cream and candies made on the premises. The confectionary sported the marble bar with a Tiffany-styled lighting fixture and marble-topped tables with steel wire chairs.

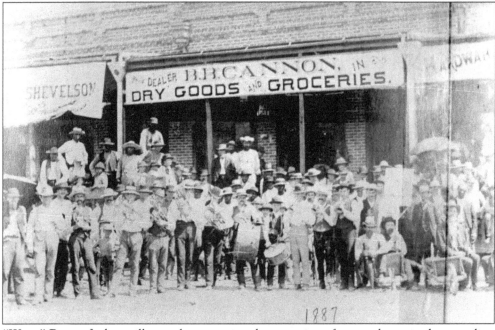

"WETS" RALLY. Jacksonville people supporting the operation of open saloons in the town line up for a rally to support their position to make the town "dry," a battle the "drys" won eventually in 1887. The sale of liquor has been banned in Jacksonville ever since except in private clubs. This photograph was taken in front of the Ragsdale building on Commerce Street.

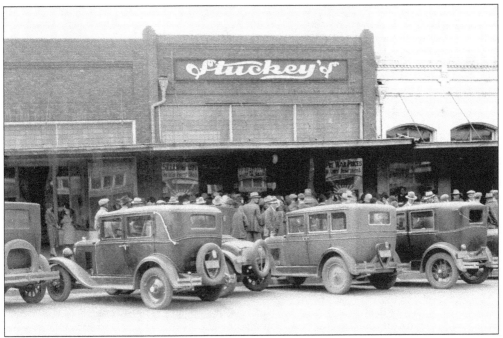

CLOSE-OUT SALE. A highlight in Depression era days was a sale of any kind. A special event was a store-closing sale such as this J. F. Stuckey Dry Goods store on Commerce Street in Jacksonville, about 1929–1930. The firm was one of a chain operating throughout East Texas. Note the automobiles from 1925–1928 parked in front of the store.

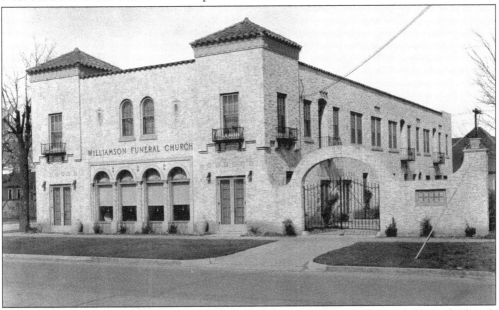

FIRST FUNERAL HOME. Jacksonville's first funeral home was the Williamson Funeral Church at Ragsdale and Larissa Streets, later the site of the Travis Clinic and now Waller Broadcasting. Opened in 1929, George Williamson Sr., owned and operated the facility, an outgrowth of the undertaking business he had operated in conjunction with his furniture company. The original building included apartments on the second floor for company personnel.

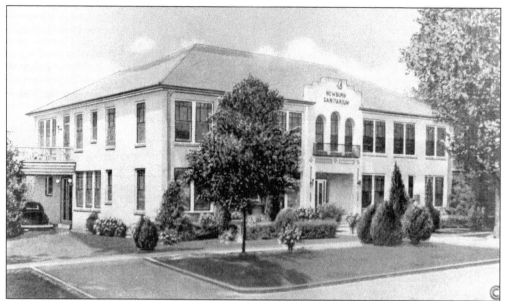

NEWBURN SANITARIUM. This hospital was founded in Jacksonville in 1917 by the late Dr. C. L. Newburn Sr. on the site now occupied by the Bonner Place Nursing Home. The sanitarium burned in 1928 and was rebuilt immediately. During reconstruction, the hospital operated from the home of Dr. Newburn's brother, Rev. and Mrs. J. M. Newburn, on Kickapoo Street. The sanitarium closed in the 1980s.

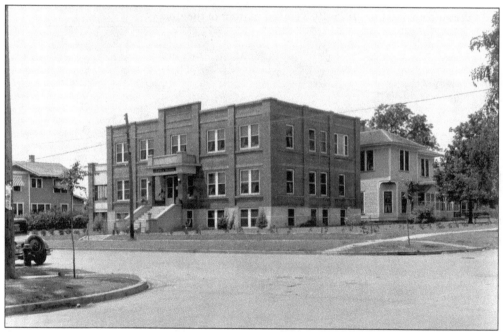

CHEROKEE SANITARIUM. Begun in 1917 in the former home of Dr. and Mrs. E. E. Guinn (in the background), the Cherokee Sanitarium later had its name changed to Nan Travis Memorial Hospital in memory of the mother of Drs. J. M. and R. T. Travis. When the brick hospital building was opened, the old Guinn home became housing for the nursing staff. Today the modern, expanded facility is known as the East Texas Medical Center, Jacksonville.

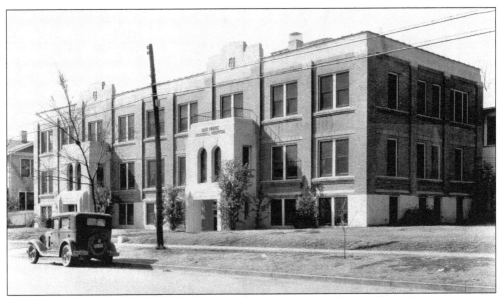

HOSPITAL EXPANSION. Nan Travis Memorial Hospital, Jacksonville, underwent several expansion projects. This one, *c.* 1937, shows the remodeling and enlargement of the first brick structure that had been opened on the same site decades earlier. This expansion enlarged the hospital to 90 beds with additional surgical and other patient care facilities.

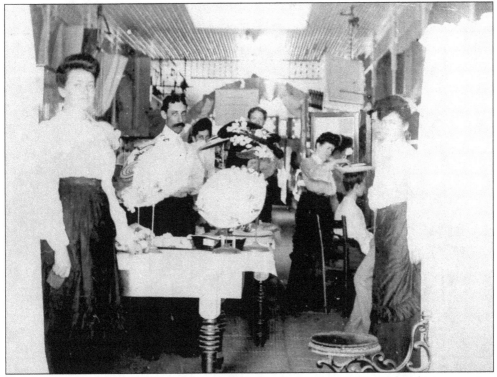

GEOTZ DRY GOODS STORE. One of Jacksonville's favorite stores in 1900 stood at the intersection of Commerce and Main Street. Pictured, from left to right, are Lula David McIlvin, Sam Geotz, Mattie Allen, Judge Russell, Pearl Key, Bon David, Alex Chapman, and Lilly Fry.

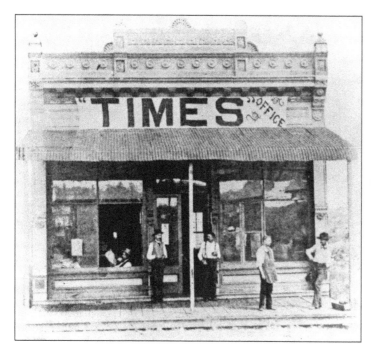

NEW BIRMINGHAM TIMES. This weekly newspaper was published in New Birmingham during the town's iron ore smelting and manufacturing boom in the 1880s. The newspaper had a circulation of 3,000 copies weekly and heralded the rise and fall of the iron smelting industry three miles east of Rusk. Pictured, from left to right, are two unidentified men, E. A. Priest, E. S. David, and unidentified.

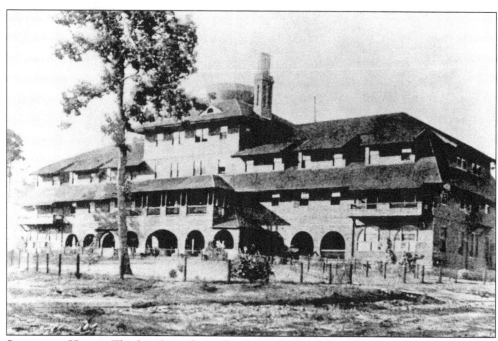

SOUTHERN HOTEL. This hotel was the pride of New Birmingham and Texas when it was opened during the 1880s iron-ore industry boom at the new town. The hotel was the site of all social events for the town. The end of the boom also doomed the hotel, which burned in 1925 after having been occupied many years by a caretaker couple.

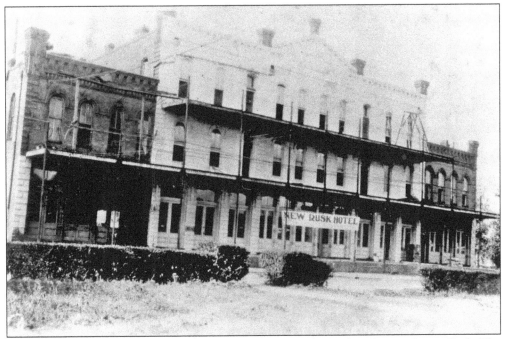

NEW RUSK HOTEL. This early hotel was a well-known stopping place for travelers in Rusk. The three-store white center building in this undated image comprised the main part of the hotel. The two-story building at the right was also used for hotel rooms at one time. Later, it housed other businesses, as did the building at the left. The structure still stands on the north side of the courthouse square.

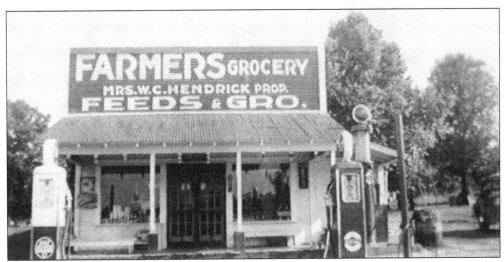

HENDRICK GROCERY AND GAS STATION. This photograph from the 1950s shows one of the oldest country stores in the area at that time at Jones Chapel.

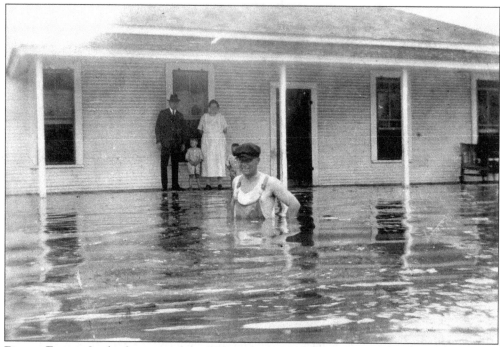

PONTA FLOOD. In the first part of the 20th century, Mud Creek burst its banks at the town of Ponta, with the results captured in this photograph. The couple on the stoop with the young child is identified as a Mr. and Mrs. Wisner. The man in the water is Dr. P. E. Jones.

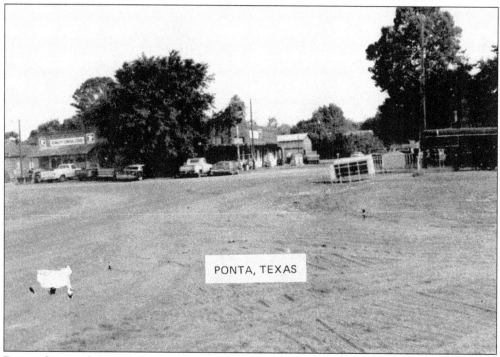

PONTA, TEXAS

PONTA STREET SCENE. A far cry from the earlier flooded streets is this 1950 view facing north in downtown Ponta. Bailey's General Store is on the left, with the white pickup parked in front.

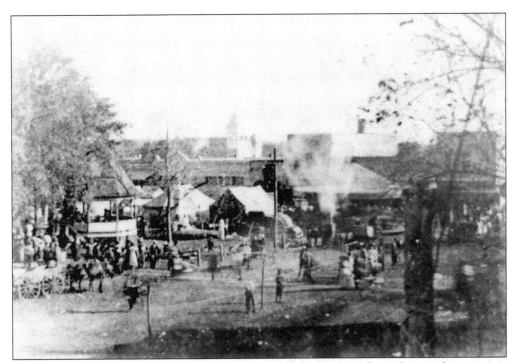

COURTHOUSE SQUARE. This view looking south sometime after 1907 shows the courthouse square in Rusk bedecked for what was apparently a county fair or similar occasion. Note the bandstand in the left foreground, the wagon and team, the tents and the monument to Confederate Civil War veterans to the right of the bandstand. The steeple in the background belonged to an early Methodist church that occupied the same site as the present church.

OLD CHEROKEE COUNTY JAIL. Located in the county seat of Rusk, the jail was demolished in 1939–1941 when the present courthouse was built with a jail on the top floor. The Rusk library was housed in the extreme left end of this building. The man sitting on the bench is unidentified.

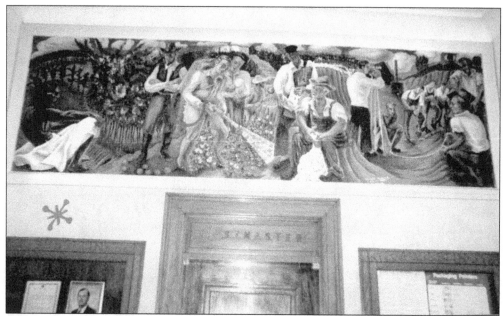

WPA Mural. One of the treasures of Rusk is the hand-painted, Depression-era murals inside the post office on Fifth Street. The project was one devised by the U.S. government to give work to artists during the years of the Depression and depicted scenes typical of the area in which the post office was located.

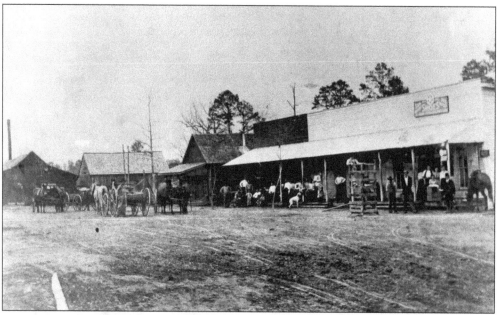

Turney Business Scene. This image of the Turney business district in 1905 shows several businesses as well as the box and crate factory in the left background, which served as the backbone of the town's economy for many years and supplemented farm income for people in the "off season." The box and crate factory has been closed for several years, and for the most part the businesses have also left the scene.

Five

TRANSPORTATION

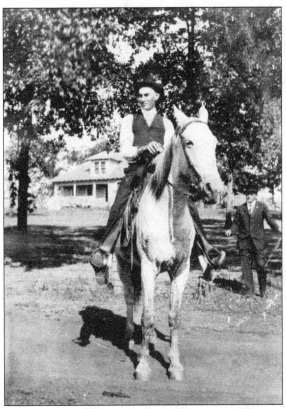

MODE OF THE DAY. From foot power to the ill-fated *Columbia* space shuttle, Cherokee County has seen it all. Residents have walked, ridden horses, driven wagons, embraced the horseless carriage, and seen the arrival of private, commercial, and military flight. On February 1, 2003, the county lost a little of its innocence as the space shuttle *Columbia* broke apart and rained down on Cherokee and neighboring counties. Even today, a walk through the woods can yield broken fragments of dreams, even as nearby children innocently ride their wheeled toys. In this photograph, an early member of the Newburn family of Jacksonville takes his saddle horse for a spin.

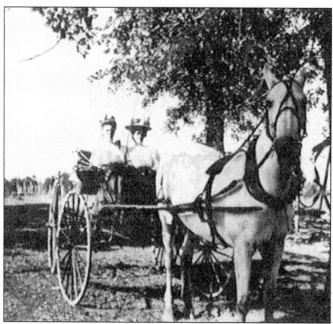

EARLY TRANSPORTATION. Two early county residents, Lillie Blackburn and Carrye Grisham, drive a one-horse wagon while dressed in their best finery.

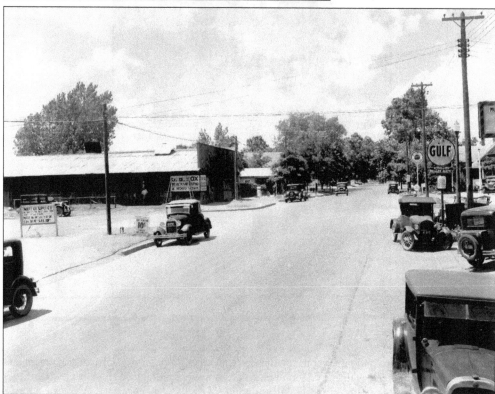

STREET SCENE. Once Cherokee County citizens embraced the automobile, Model As and Model Ts became the early automobiles of choice in Jacksonville. This scene, looking south on Bolton Street with Cherokee Street entering from the left, shows the proliferation of the auto and also the cost of gas: 10¢ per gallon in 1928.

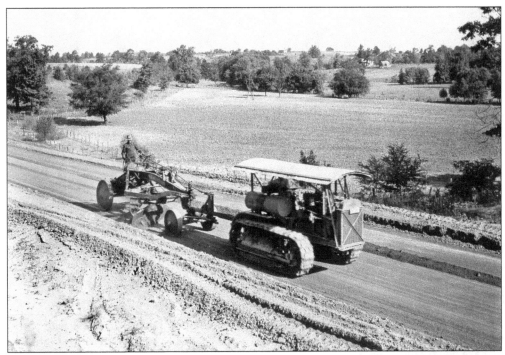

ROAD MAINTENANCE. This 1937 model mule-powered road grader was used to build and maintain county roads. Though no longer used, this relic is the property of Precinct 3 and is on display at the county barn. From time to time, the grader is featured in local parades.

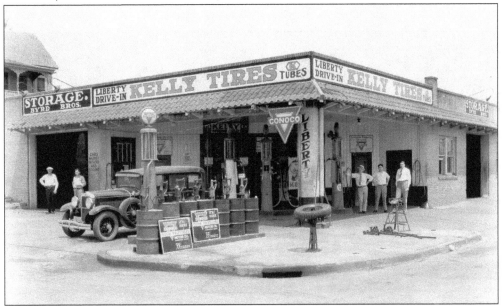

LIBERTY DRIVE-IN. Three Byrd brothers operated this gasoline station at Main and Woodrow Streets as a successor to the livery business their father operated during earlier Jacksonville days. The firm also operated a 24-hour taxi service and housed the town's fire trucks. At left in this post-1932 photograph is city fireman Roy Merk, with Herman Byrd beside the gasoline pump. The other people are unidentified.

EARLY ALTO CAR. This image, believed taken in 1910, shows a Dr. McClure's car, one of the first in the Alto area. Physicians often were the first in an area to have cars in order to be able to make house calls faster.

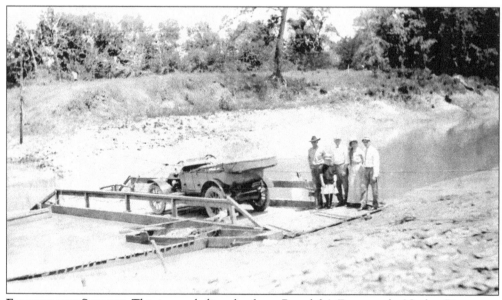

FORDING THE STREAM. This image, believed to be at Ragsdale's Ferry on the Neches River west of Jacksonville, shows J. L. Brown, Allen Spraggins, Elizabeth Brown, Mrs. J. L. Brown, and an unidentified ferry operator. Note the right-hand drive of the Case automobile, an early venture of the Case farm machinery firm.

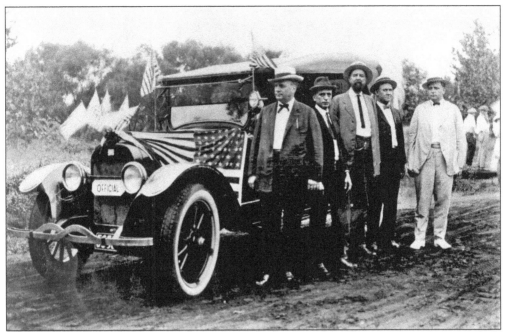

ANNIVERSARY LEADERS. Jacksonville's Golden Anniversary dignitaries pose before a new Buick touring car just before the commencement of the town's 50th anniversary celebration in 1922. Shown, from left to right, are district congressman John C. Box,; Charles C. Bando, operator of Bando's Candy Kitchen; M. L. "Bud" Earle, general chairman of the weeklong event; Tol G. Smith, First State Bank officer; and Mayor T. E. Acker.

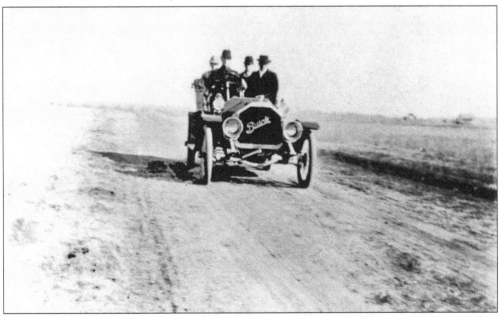

THIRD AUTOMOBILE IN THE COUNTY. This Buick was the property of proud owner D. B. Tucker, an early merchant in Jacksonville, shown riding in the back seat with his son Paul. The driver is unidentified; next to him in the front seat is D. B.'s son Knox. Note the right-hand drive and the lack of a windshield or top. The headlights burned carbide and had to be lighted with a match.

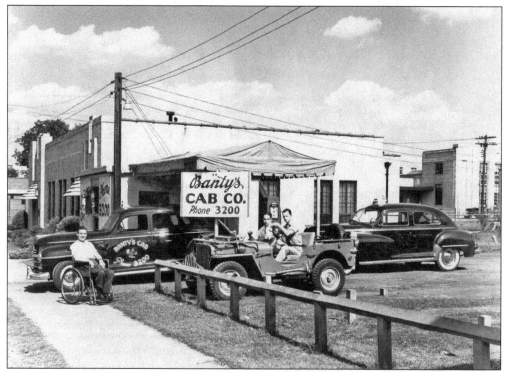

BANTY'S CAB COMPANY. A fixture in Jacksonville in the 1930s to late 1950s was Banty's Cab, owned and operated by Edwin "Banty" Jones on East Commerce Street. The company offered 24-hour service as well as a wake-up telephone call service. Jones, shown here in a wheelchair, had been paralyzed in a hunting accident several years earlier.

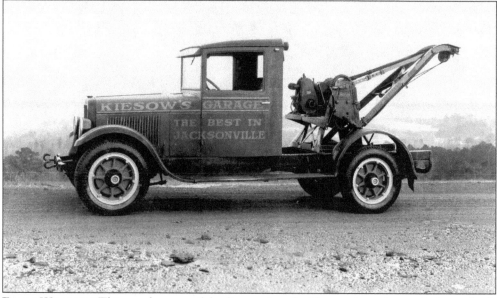

EARLY WRECKER. This wrecker, one of the first equipped with a modern power winch, was built by Gus S. Kiesow of Jacksonville. When Kiesow opened his first garage at South Bolton and Rusk Streets in March 1912, the town had 22 automobiles.

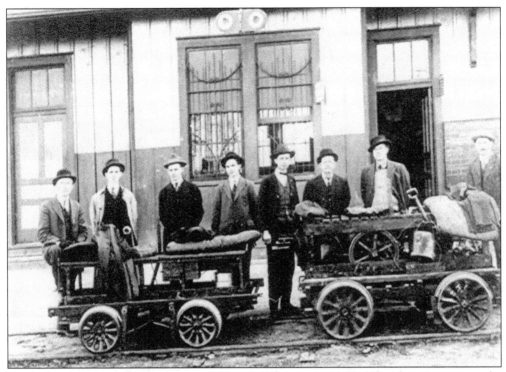

ALTO RAIL TRAVEL. One of the favored means of transportation in Cherokee County was the railroad. In this photograph taken in Alto around 1921, eight unidentified men pose with a railroad handcar, which was used to check the tracks for problems.

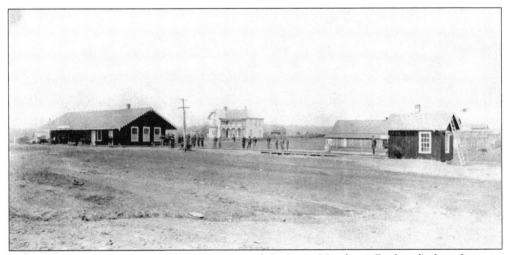

FIRST RAILROAD STATION. The International & Great Northern Railroad's first depot in Jacksonville, opened when the railroad established present-day Jacksonville in 1872, is shown at the left. The section house for maintenance-of-way crews is on the right. The depot was moved several times until the railroad discontinued passenger service and razed it in the late 1960s.

BUSY RAILROAD CENTER. Hidden behind the boxcars in this 1930s picture is the Texas & Pacific Railroad depot, located on what was then Oak Street near South Bolton Street in Jacksonville. The two-story building behind the depot was the site of the Sour Rag café, long a hangout for high school and college students.

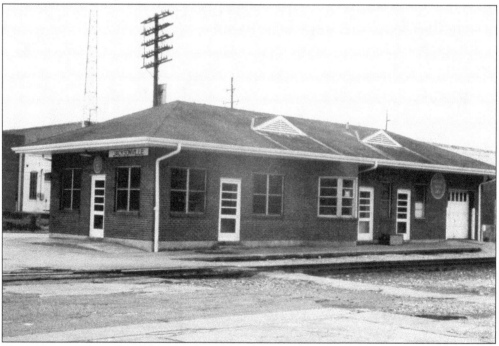

FINAL DEPOT. The railroad depot in this 1950s photograph was the last one in Jacksonville. The town, established by the railroad, was a center of operations for many years, with four different lines running through at one time. By the time this depot was razed in the late 1960s, there was only one line left, the Union Pacific, which no longer carried passengers.

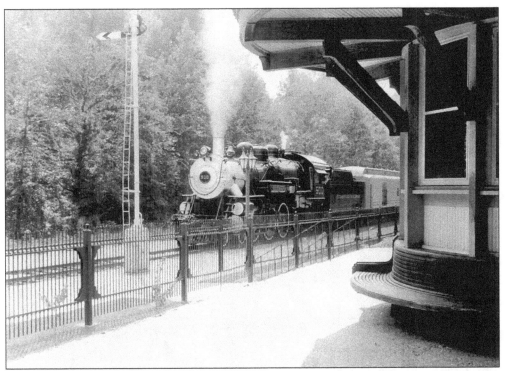

RESTORED ENGINE. Steam engine No. 500 pulls an excursion train into the station at Rusk at the east end of the Texas State Railroad Park. The railroad, which offers a glimpse into the history of travel, is a popular destination for thousands each summer.

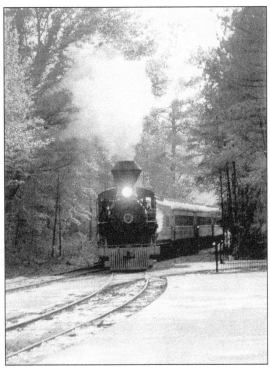

TEXAS STATE RAILROAD. This rail line between Rusk and Palestine was originally built by the Rusk State Penitentiary using prison labor. Now a scenic excursion railroad, it is the state's longest park.

71

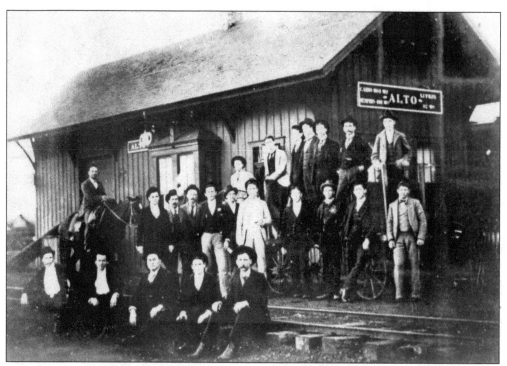

ALTO DEPOT. Although the date of this photograph of the Cotton Belt Railroad Station in Alto is unknown, it is typical of the small depots that were opened along the line operating between Tyler and Lufkin. Originally the Kansas & Gulf Short Line Railroad, the narrow-gauge line was merged with the St. Louis–Southwestern Railroad, better known as the Cotton Belt. The K&GSL began service between Tyler and Lufkin in 1885.

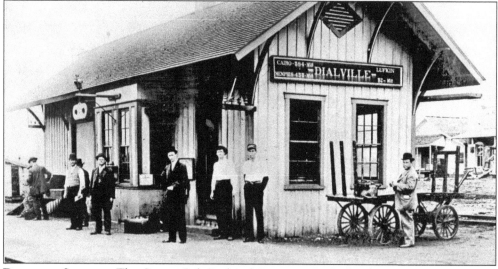

DIALVILLE STATION. The Cotton Belt Railroad Station at Dialville, shown here around 1910, was built in 1884 when the Kansas & Gulf Short Line, a narrow-gauge line, first came through Cherokee County. The station no longer exists. Pictured, from left to right, are C. D. Jarratt, G. L. Grisham, C. W. Benge, Dr. J. W. Moore, an unidentified salesman, T. J. Durrett, "Boss" Walker, and another unidentified salesman.

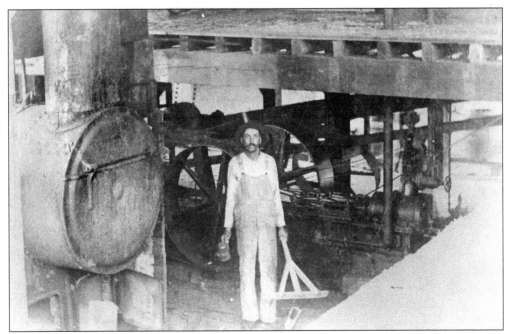

PONTA COTTON GIN. Farmers did not have to carry their cotton far to have it prepared for market. The Ponta gin, located near the railroad tracks, began operation in the late 1880s. The proximity of the railroad facilitated shipping the ginned cotton to faraway markets.

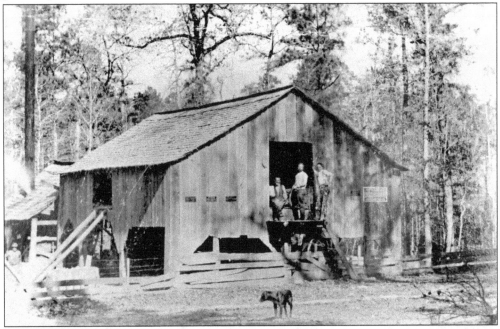

MEAZLE COTTON GIN. The Meazle gin at Sardis, opened in 1905, was one of many scattered around Cherokee County. Pictured to the extreme left behind the gin is "See" Meazle. Shown in the upper door are Charles Wesley Meazle (left), H. Hancock (center), and "Pete" Meazle. The sign on the building advertised cottonseed hulls and herbs and iron, apparently a patent medicine. Cherokee County has not produced cotton in many years.

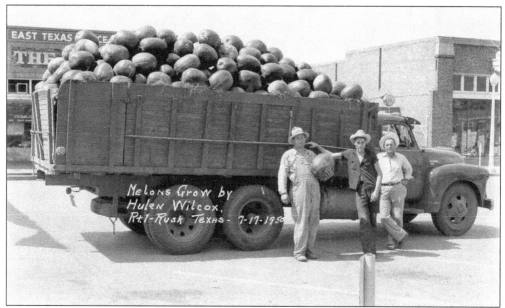

WATERMELON TIME. Hulen Wilcox of the Rusk area, holding a melon, shows off a typical load of watermelons grown on his farm and brought to Jacksonville for sale. The other two men are unidentified. At one time, watermelons were a big source of farm income and were shipped in cattle cars on layers of hay from Jacksonville to markets throughout the East and North.

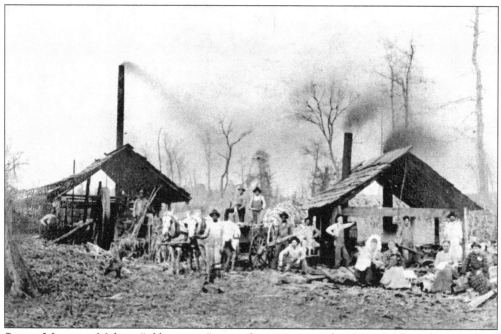

SYRUP MAKING. Making "ribbon cane" syrup from sugarcane has been a fall tradition in East Texas for generations. The syrup is made for home consumption and also as a cash source for farmers. This mill was operated in 1902–1903 in the Corine community by Byrd Simpson. All those pictured are members of the Simpson family or their farm hands.

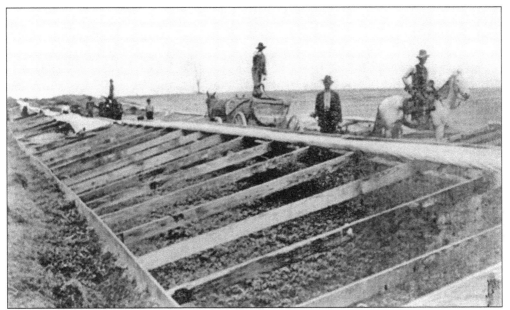

KING TOMATO. Cotton, peaches, and truck gardens quickly gave way to a new "king" of crops—tomatoes. Morrill Orchard Company near Alto built these cold frames in 1900 to harden off the tender tomato plants before transplanting them in the open fields. The only ones identified in this photograph are W. L. "Lum" Nicar (on horse) and Tom Nicar (to the left of Lum).

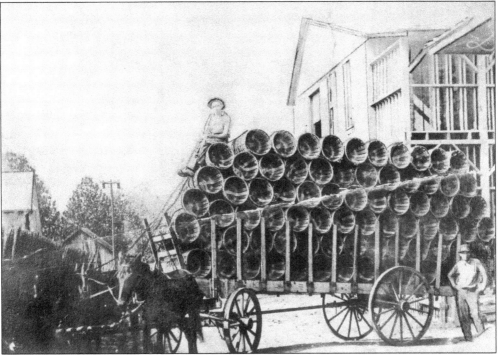

BASKET BUSINESS. The tomato industry spawned many other businesses. In this 1908 photograph, two unidentified men are delivering a load of tomato baskets from Aber Box and Basket Factory in Jacksonville to a tomato shed.

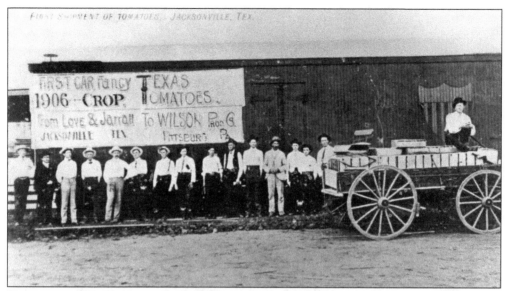

TOMATOES, 1906. The first carload of Jacksonville area tomatoes are loaded at the I&GN Railroad siding on Wilson Street for shipment to eastern and northern markets on July 2, 1906. Note that these tomatoes were shipped ripe in four-basket crates that the farmers made and packed at home for shipment under ice to prevent spoilage en route.

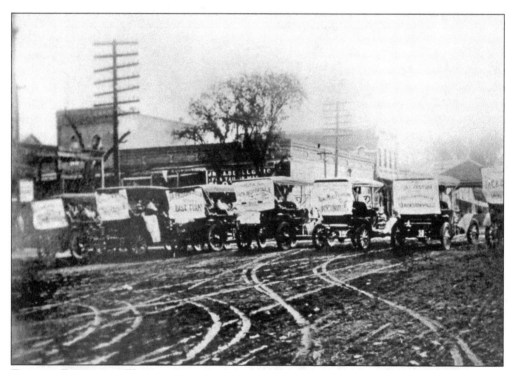

TOMATO BOOSTERS. This seven-automobile caravan of Jacksonville businessmen lines up on an unpaved Jacksonville street before leaving for a tomato promotion trip to Galveston in 1912 designed to help the sale of Jacksonville tomatoes. For many years, Jacksonville citizens made similar annual trips to promote the sale of Cherokee County's most famous cash crop.

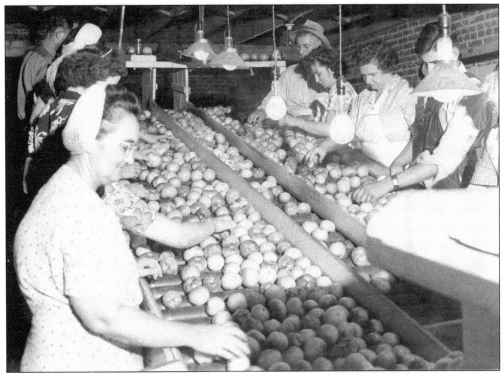

PACKING TOMATOES. Workers at the Dublin tomato shed in Jacksonville pack tomatoes for shipment to markets. Tomatoes were bought from farmers and taken to the packing sheds where they were graded for quality and size before being packed, and shipped to market via railroad. The tomatoes in the center chute were culls and were returned to the farmers, who were paid only for fruit that met standards. The only one identified in this photograph is Sam Boles (wearing hat).

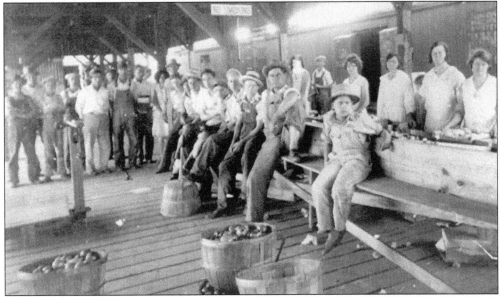

ALTO TOMATO SHED. All areas of the county took part in the tomato deal. This packing shed, owned by Fred Sartain, was located in Alto. This photograph was taken in the 1940s.

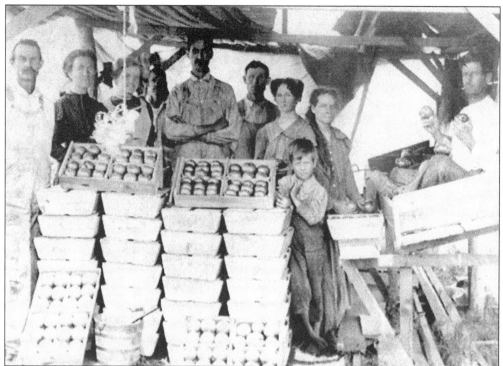

CENTRAL HIGH TOMATOES. This operation took place on the Dickey farm at Central High around 1910, with these "pink" tomatoes being picked and packed on the farm. Each box held four baskets of tomatoes. Farmers bought both the baskets and unassembled pieces of the boxes in town at the beginning of the season. Farm owner Hugh Dickey, with arms folded, is in the center of this photograph.

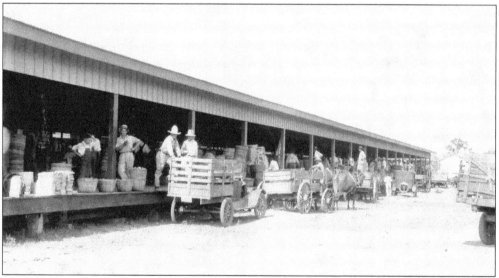

TOMATO DAYS. Farmers unload tomatoes at the Shoemaker packing shed in Jacksonville for grading, packing, and shipping to markets in the North and East. Notice the mix of Model T and Model A trucks and mule-drawn wagons in the unloading line in this photograph from the early 1930s.

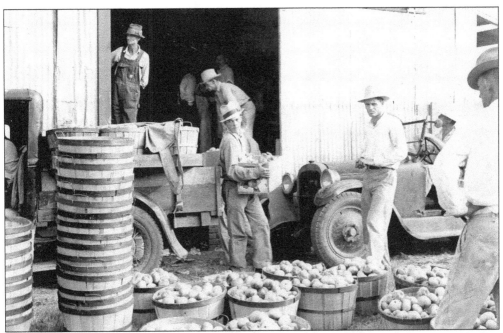

UNLOADING TOMATOES. Unidentified workers unload tomatoes at the Bruno packing shed in Jacksonville. Tomatoes were graded for quality and size, packed in 30-pound lugs, and shipped green to markets in the East and North. The "green wrap" tomato shipping practice was developed on the experimental farm at Morrill south of Alto. Until then, tomatoes were shipped ripe and under ice in four-basket crates that farmers assembled and packed on their farms.

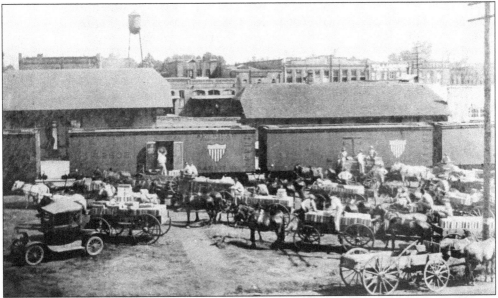

PINK DEAL SHIPPING. Jacksonville area tomato growers line up their wagons to load ripe tomatoes on a railroad siding. The fruit went to market under ice to prevent spoilage. The date of this photograph, taken from Woodrow Street (then called North Front) looking south, is unknown, but the First Methodist Church, with its dome barely visible in the right center background, was built in 1909. The water tower is located in City Park.

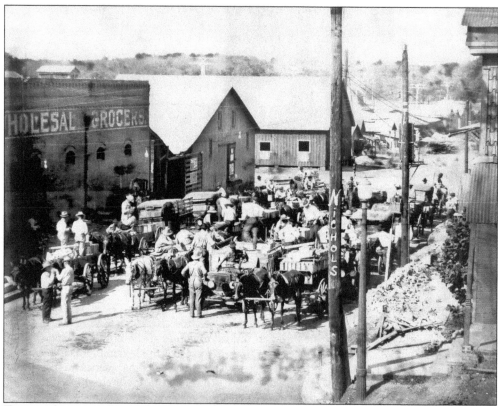

Tomato Shipping. Farmers' wagons and Model T Ford trucks deliver tomatoes for shipment from Jacksonville in the early 1900s of the famous Jacksonville tomato deal. This scene took place on Wilson Street (then known as South Front) between Main and Ragsdale Streets.

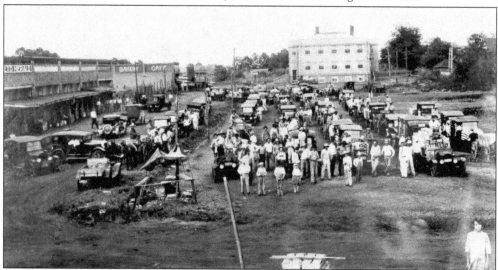

Alto Tomato Deal. Farmers' wagons, cars, and trucks fill the Alto "Cotton Yard" in the busy days of tomato shipping time, usually from late May until early June. The predecessor to the present-day A. Frank Smith United Methodist Church is visible in the right background of this 1924 or 1925 image.

84

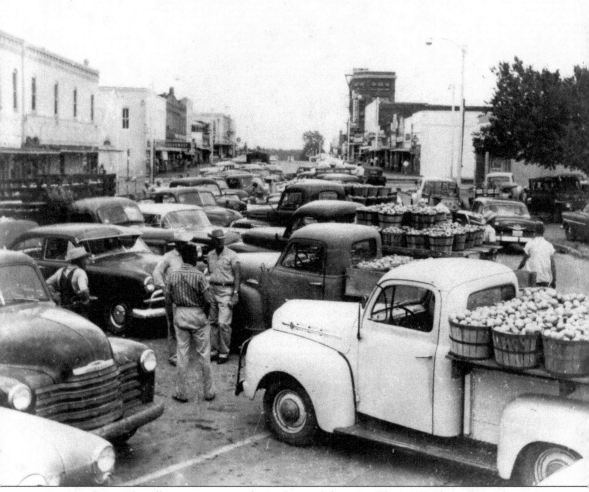

CATFISH ROW. Not all tomatoes were shipped out of the area. This 1950s farmers' market on Catfish Row (the western end of Commerce) in Jacksonville existed to sell tomatoes and other produce to residents.

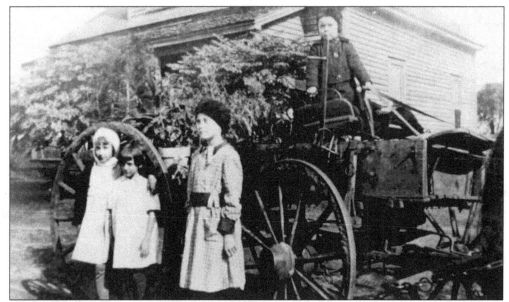

FARM WAGON. These four children stand beside the wagon used for their family's trips to town, for use on the farm, and even for play time. The location pictured is the Enterprise community northeast of Jacksonville known as Bug Tussle. This 1920 photograph shows, from left to right, Billie Deason, Helen Cotton, and Clara Ruth Isaacks. The seated child is unidentified.

TOMATO ROYALTY. Two candidates for queen of the 1941 National Tomato Festival in Jacksonville pose in a tomato field as part of the pre-festival publicity, which appeared in newspapers and magazines throughout Texas and the Southwest. From left to right are Frances Stevens, 1941 queen; Kathryn Turner, 1940 queen, and Fannie Byrd Bolton, 1941 runner-up. In 1941, World War II brought an end to the event.

Seven

INDUSTRIES

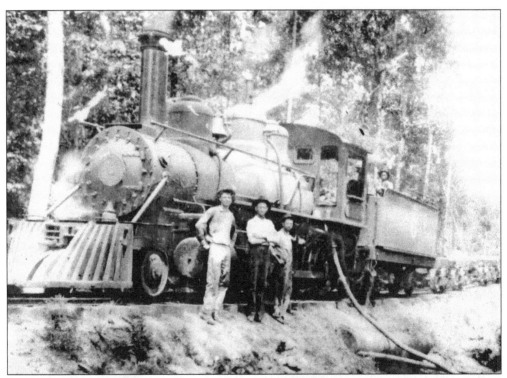

LUMBER COMPANY TRAIN. Although iron ore, oil, and even a prison (later a state hospital) played their parts in Cherokee County's history, it was the railroad that "put Cherokee County on the map." Even agriculture became dependent on the train for transport to markets. Railroads created towns, moved towns, and at times even killed towns. In this 1920 photograph taken at Wildhurst in southern Cherokee County, a Chronister Lumber Company locomotive takes on water from a creek to make steam. The locomotive was fueled by wood. Shown, from left to right, in this 1920 photograph are ? Ramsey, ? Starling, Harris Anderson, and Fisher Stokes.

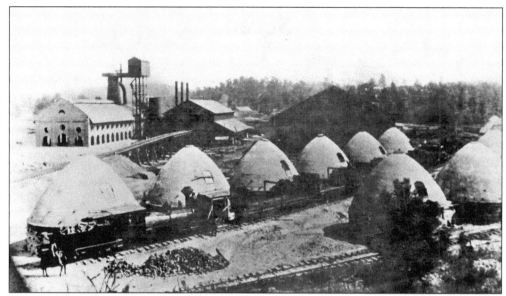

STAR AND CRESCENT FURNACE. This is one of the larger iron ore smelting operations at New Birmingham east of Rusk. Like the nearby Tassie Belle Furnace, this one was killed by the discovery in Alabama of abundant coal, which in turn gave that state's iron ore industry new life and doomed its budding competition in Cherokee County. New Birmingham ceased to exist by 1900.

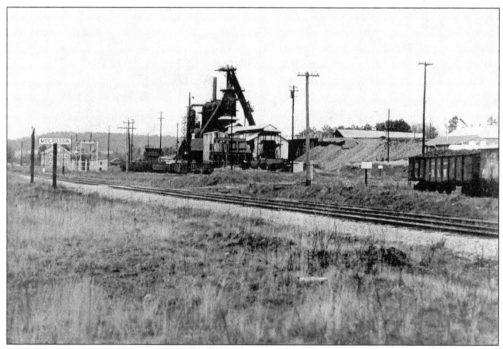

IRON INDUSTRY. Valencia Iron and Chemical Company established this plant during World War II near Oakland to produce iron and chemicals from the iron ore deposits in the area. Armco Steel and Sheffield Steel later operated part of the facility to process iron ore for their smelters near Houston. Deposits were exhausted and the plant closed soon after the war.

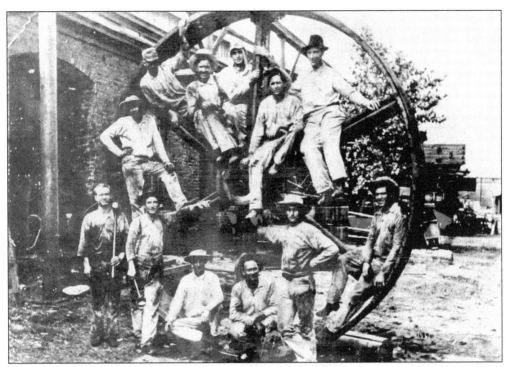

GIANT MILL WHEEL. Manufactured in the old Rusk State Penitentiary iron works by prisoners who provided labor for the smelter and foundry, this wheel weighed 9,000 pounds. The prison smelter was also used to make all of the ironwork used in the Texas State Capitol in Austin, including the huge arches for the dome. Other intricate iron-work was made by inmates, until the prison was closed in 1913.

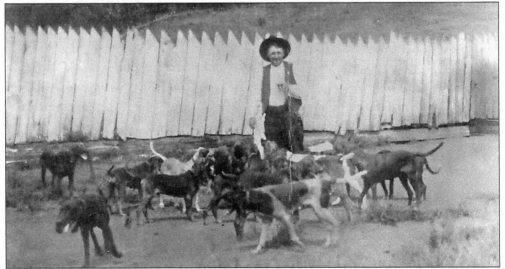

DOG MASTER. All industries at the Rusk State Penitentiary used convict labor. Although the items produced were superior and the convicts were rightly proud of their work, they were never allowed to forget that they were prisoners. One constant reminder was the dogs. In this image from 1890, Jefferson Whitfield Smith, dog master at the prison for many years, is pictured with his charges.

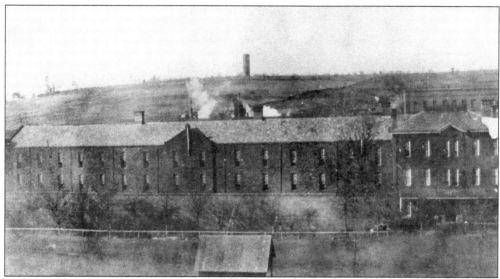

RUSK PRISON IRON WORKS. The iron works of the state penitentiary was located in front of the current Rusk State Hospital. When the building was torn down, a park was put in its place. The foundry closed in 1913.

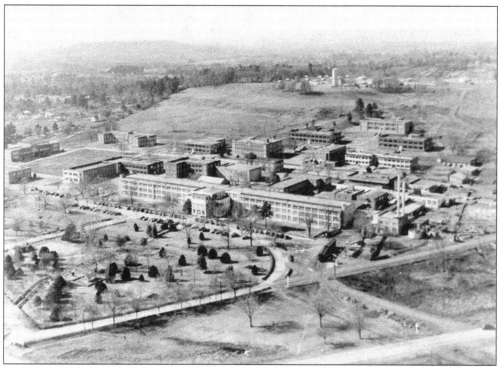

RUSK STATE HOSPITAL. Still one of the largest employers at Rusk, the state hospital has undergone many changes since the days when it served as the Rusk State Penitentiary. This aerial photograph was taken before 1958, at which time the railroad line shown was abandoned. The central building (protruding part of front building) is part of the original prison. Today, two prisons are located on the hill behind the hospital.

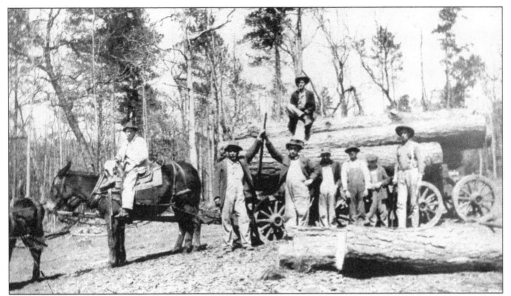

EARLY LUMBERING. The lumber industry has long been an important part of Cherokee County life, thanks to its thick forests of both pine and hardwood. The workers shown in this 1900 or possibly earlier photograph, from left to right, are A. T. Work, Charley Work, Lester Lochmiller, John Work, Pete Simmons, Jack Work, John Early, and Henry Dowling (on logs).

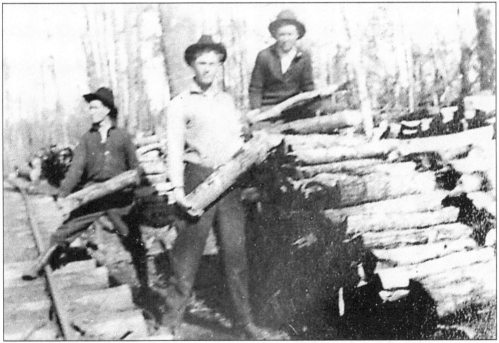

LOCOMOTIVE FUEL. Somewhere along the line of the Blount-Decker Lumber Company logging railroad, operating out of the firm's mill in Alto, crews stack wood fuel for the line's locomotives. The rail line prowled southern Cherokee County, hauling cut timber to the big mill in Alto for sawing and finishing. Will Dixon of the Campground community is in the center of this group. The others are unidentified.

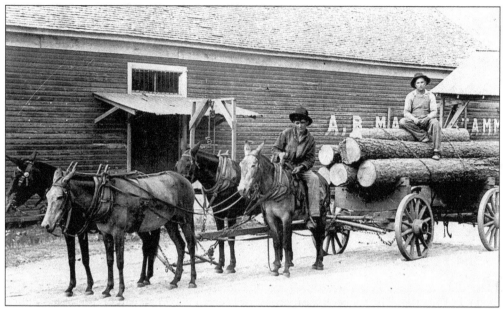

LOGGERS. This photograph likely dates from the early 1920s, when mule teams were a standard method of hauling logs to the sawmills. Although the load is rather light for these two teams, the wagon is the right size for the load. Often loggers would have three and four teams to a load on the sturdier wagons, many of which were 8- and 12-wheelers.

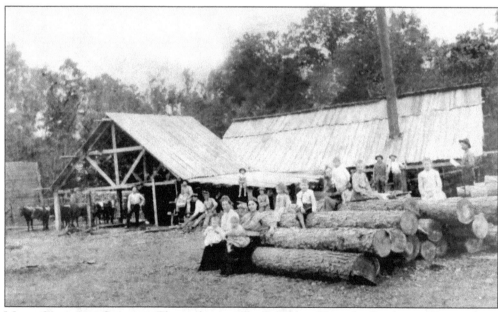

MATT CHANDLER SAWMILL. This early sawmill operated on Turnpike Creek near Turney about 1906. The people in the background are unidentified, but on the logs, from left to right, are (first row) Mrs. John Chandler and Everett Chandler (on her lap), an unidentified woman and child, Ruth Chandler, Wylie Chandler, Velma Chandler, Beth Chandler, and Bud Thompson, 2 unidentified men (in front of shed), an unidentified girl, John Chandler, and Richard Chandler (on the roof).

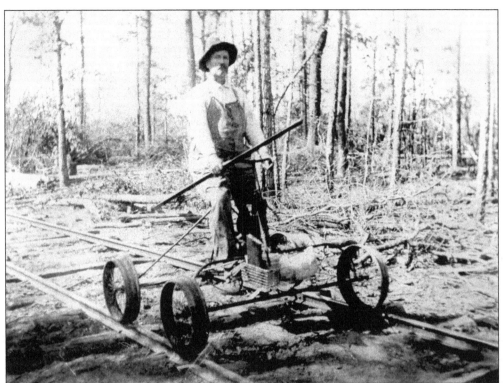

LOG SCALER. John H. Singletary pedals his "company car" sometime after 1908 on his rounds as a log scaler for the Blount-Decker Lumber Company based in Alto. Note the scaling stick in his right hand and the scale book, lunch sack, and water jug in the basket. The lumber company operated an extensive private railroad system for hauling cut timber to its mill in Alto.

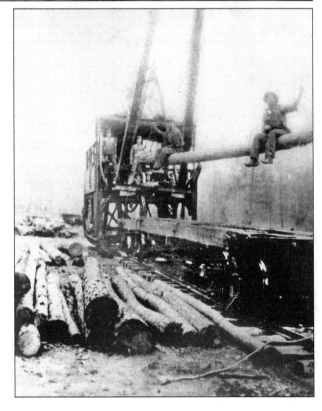

LOG LOADER. This steam-powered machine was used to load logs on lumber company railroad cars for transporting to sawmills via the lumber company's own railroad, which ran through the forests to wherever timber was being cut. The loader operated on rails to allow the long boom to extend over the log cars for loading logs in tall stacks. The site of this operation is the Neches River near Fastrill in 1926 or 1927.

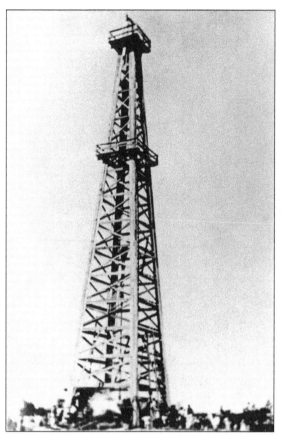

EARLY OIL VENTURE. This well on the L. F. Hill farm near Alto was one of the early attempts to discover a commercial oil field in Cherokee County. Drilled in the fall of 1925, the well came in a dry hole. Decades later, oil and natural gas fields were developed in the Alto area. Some are still producing, although never at the level of the East Texas Oil Field.

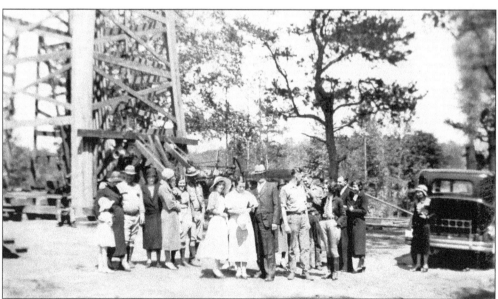

PONTA OIL ATTEMPT. A large group of interested citizens at the Paine farm near Ponta gather to have their picture taken in the 1920s with an oil well, which was not a successful venture. After the East Texas Oil Field came in, all areas of East Texas were bitten by the "oil bug."

COLLITON PRODUCER. This oil well east of Jacksonville in the Mud Creek area is making a head of flowing oil in 1925. The well was one of several Jack Colliton drilled in that general area. Although he ran out of financing, he did bring the oil industry's attention to Cherokee County, where small amounts of oil and gas are produced to this day.

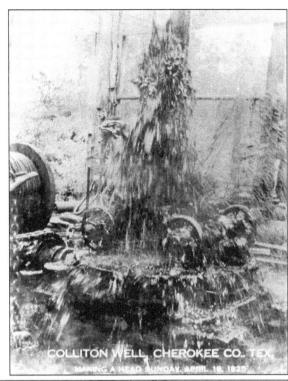

COLLITON WELL, CHEROKEE CO. TEX.
MAKING A HEAD SUNDAY, APRIL 19, 1925.

OIL FIELD CONFIRMER. This well, shown in the 1920s, confirmed that the Carey Lake-Boggy Creek area straddling the Neches River west of Jacksonville was a viable producer of oil. The field is still producing, although at a reduced level than in the earlier days. The man in the photograph is unidentified.

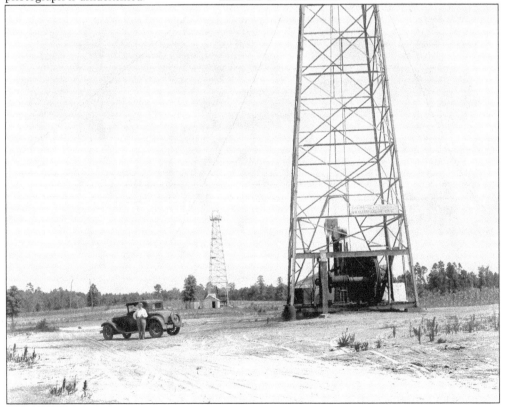

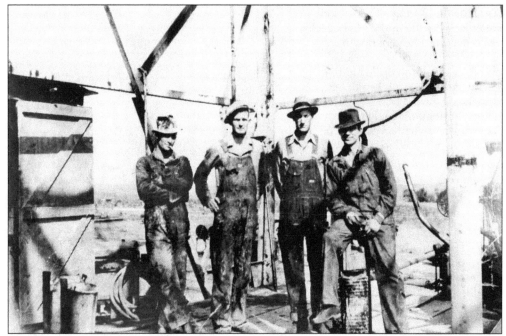

OIL PRODUCER. Crewmembers drilling an early producer of oil in eastern Cherokee County pose for a photograph on the deck of the drilling rig, c. 1930. The well, located between New Salem and Striker Creek near the Cherokee-Rusk county line, confirmed oil production in the area where several low-volume wells were completed later. Crewmembers, from left to right, are Don Acker, Curly Cleaver, Rob Nance, and Shiral Arnwine.

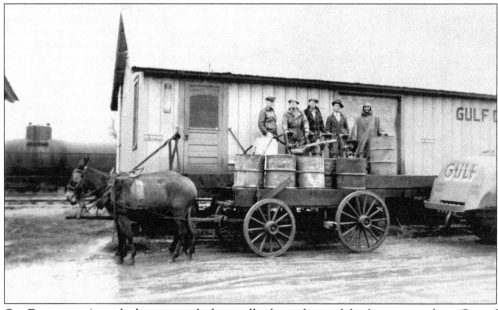

OIL BUSINESS. As with the tomato deal, not all oil was destined for far-away markets. One of the early oil and gasoline consignees in Jacksonville was operated out of this establishment on Wilson Street. Shown in this photograph from the 1930s, from left to right, are John Rountree, Clifton Hutto, unidentified, R. R. Childs, and unidentified.

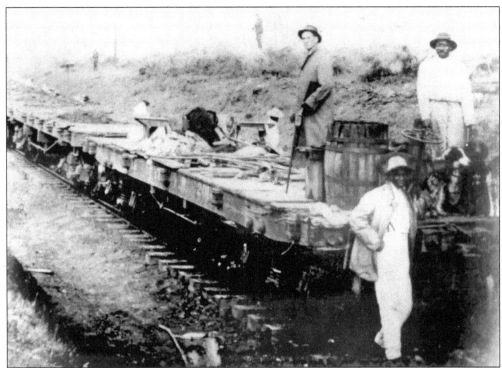

PRISON RAILROAD CREW. This *c.* 1900 Rusk State Penitentiary railroad crew included guards with guns and dogs. Prisoners who tried to escape from the work crews were quickly tracked down by the dogs. This crew is building onto the track that served the prison system. The railroad hauled iron ore and timber for making charcoal for the furnace at the prison.

SECTION CREW. Snipers, also called Gandy Dancers, work on the Southern Pines logging railroad main line west of Sardis about 1928. Snipers repaired and maintained the track. Those shown, from left to right, are either Edgar McAdams or Ray Salmon, Shine Burchfield, B. D. McComb, and Raleigh Burchfield.

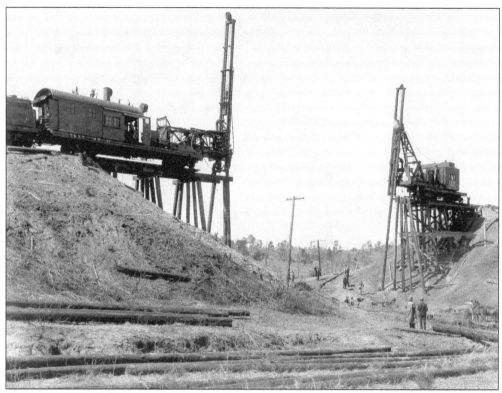

BUILDING T&NO TRESTLE. Railroad bridge gangs are busy building the trestle for the line over the creek north of present West Larissa Street in Jacksonville in 1902. Note the long wooden pilings being driven into the ground by steam-powered pile drivers and the mule-drawn equipment used for grading the land and dragging the pilings into place for the pile drivers.

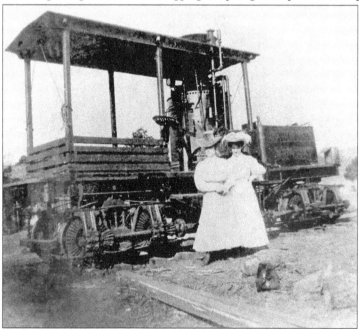

SHAY LOCOMOTIVE. A rare Shay industrial locomotive in the late 1800s at an East Texas sawmill is the background for this photograph of two unidentified young ladies. Power was transferred to the wheels by cogs, which enabled the locomotive to run on iron or wood rails and on very uneven roadbeds. This type of locomotive had much more traction than rod-driven locomotives and could operate on steeper grades.

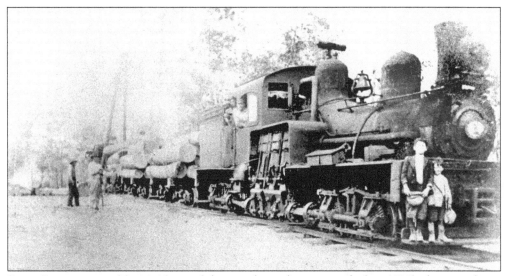

SHAY LOCOMOTIVE NO. 1. None of the people in this very early (pre-1900) photograph are identified. These locomotives prowled the woods of southern Cherokee County for years hauling cut timber to the Blount-Decker Lumber Company mill at Alto for sawing and finishing and shipment. Although they had greater traction and could maneuver sharper curves than the rod-driven types, they had to operate at slower speeds.

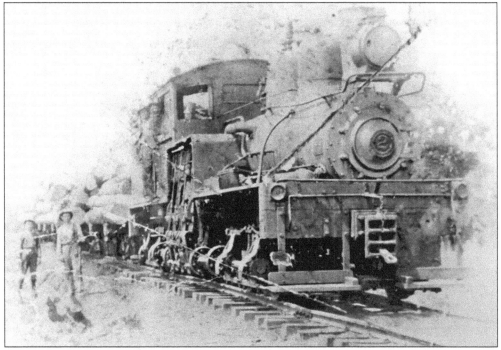

SHAY LOCOMOTIVE NO. 2. This Shay-type locomotive, operated by the Blount-Decker Lumber Company at Alto, had three cylinders, which operated the geared driving trucks. Like the firm's Shay No. 1, this one operated on standard gauge track, was able to negotiate sharper curves, and had more power than rod-driven locomotives. The men in this pre-1900 photograph are not identified.

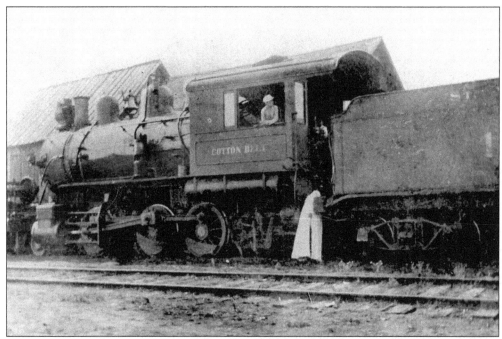

COTTON BELT MOGUL. This early Cotton Belt railroad "mogul" locomotive sits on a side track on the Tyler-Lufkin line in Cherokee County during its daily freight run between the two cities. The mogul, a standard on many railroads for decades, had two-wheel lead trucks and six drivers. The men in this early 1900s photograph are unidentified.

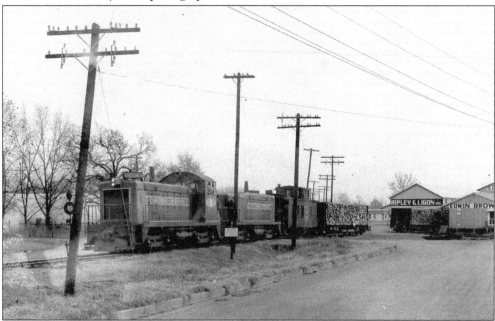

FIRST DIESEL LOCOMOTIVE. Diesel-powered locomotives came to Jacksonville for the first time in the 1950s when this Electromotive Company demonstrator "cow and calf" made a test run on the Cotton Belt Railroad to determine whether or not it could handle the tonnage of the line's daily freight service. The Cotton Belt line was abandoned in the 1980s.

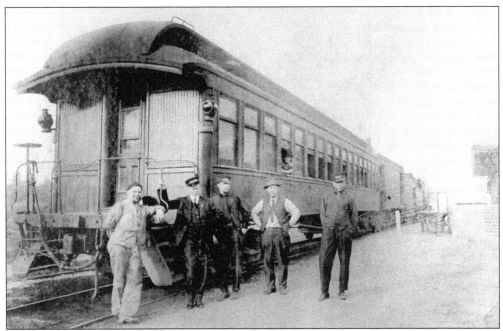

PALESTINE BRANCH RUN. Crewmembers of the Texas & New Orleans Railroad's Palestine Branch Run train, which operated between Gallatin and Palestine via Rusk, pose before starting a run on what is now the Texas State Railroad between Rusk and Palestine. Pictured, from left to right, are an unidentified engine crewman, conductor Robert Devereux Black, brakeman Tracy Bolton, and two other unidentified crewmen.

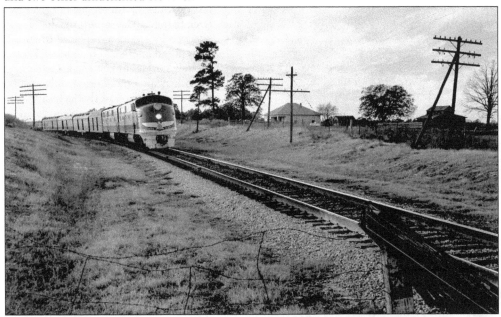

THING OF THE PAST. This Missouri-Pacific Eagle passenger train, photographed in the late 1950s, no longer runs. The Eagle was one of the premier passenger trains in the nation immediately after World War II. Featuring all-new equipment, luxury facilities, and fast travel, it stopped regularly in Jacksonville.

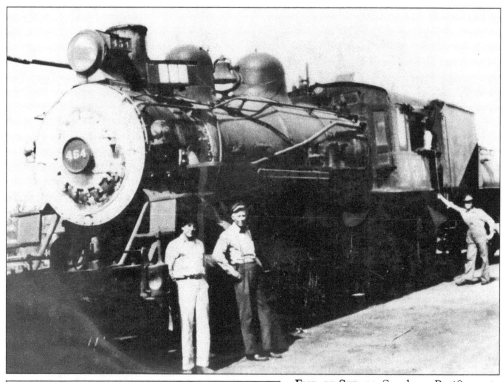

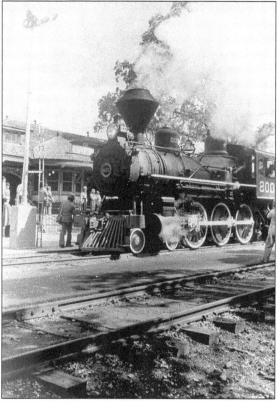

END OF STEAM. Southern Pacific locomotive No. 454 was one of the last two steam-powered locomotives to operate out of Jacksonville as diesel-powered locomotives replaced them. This photograph, taken about 1955, shows Charlie Fling at the far left. All others are unidentified, although they are known to be the Jacksonville roundhouse crew responsible for servicing the locomotives and keeping them in operation.

STEAM RESTORED. In the 1990s, Engine No. 200, an 1896 Cooke 4-6-0, pauses at the Rusk depot on the Texas State Railroad before leaving on a three-hour excursion to Palestine. The railroad operates colorful full-size iron horses over a 25-mile trip through the deep East Texas pine forests.

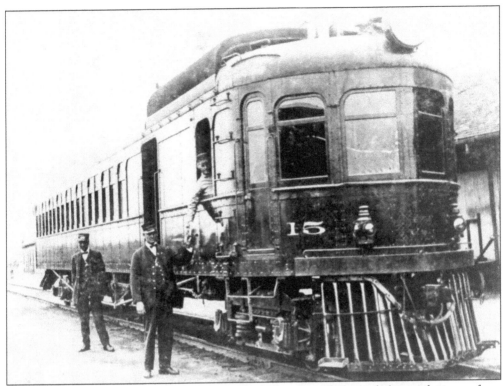

THE JITNEY. Cotton Belt Railroad Motorcar No. 15 stands ready for its daily round-trip run from Tyler to Lufkin through Jacksonville. Typically called the "jitney," the motorcar handled passenger, mail, express, and light freight business along the line. The runs were stopped in 1949.

END OF ANOTHER ERA. The Cotton Belt jitney leaves Alto on its final run in 1949, which ended passenger, mail, express, and light freight service of the railroad dating from 1883 to 1885, when the predecessor Kansas & Gulf Short Line Railroad operated between Tyler and Lufkin. Citizens hung a funeral wreath on the rear of the car before it left that station.

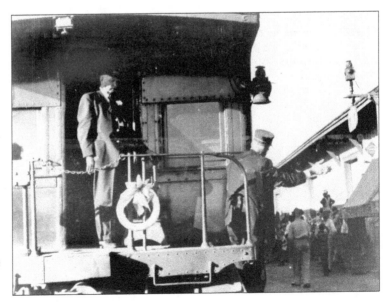

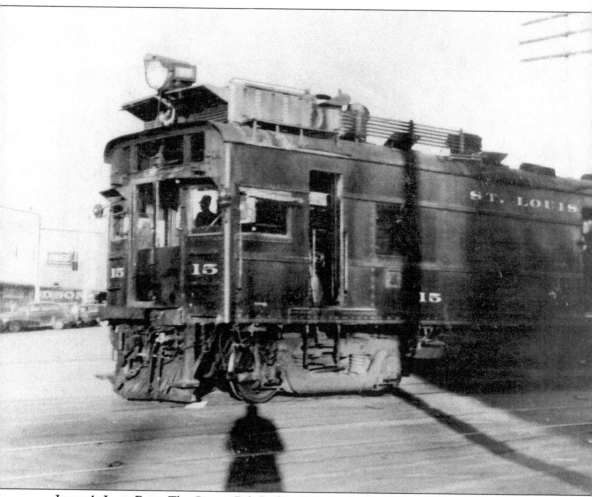

JITNEY'S LAST RUN. The Cotton Belt Railroad's jitney leaves Jacksonville in November 1949, on its final run before the railroad stopped daily train service between Tyler and Lufkin. The service marked the end of what had once been two trains daily in both directions from the days when the railroad began this service in 1885. D. C. Reynolds, a Cherokee County native, was motorman on the last run.

Eight

RECREATION AND ENTERTAINMENT

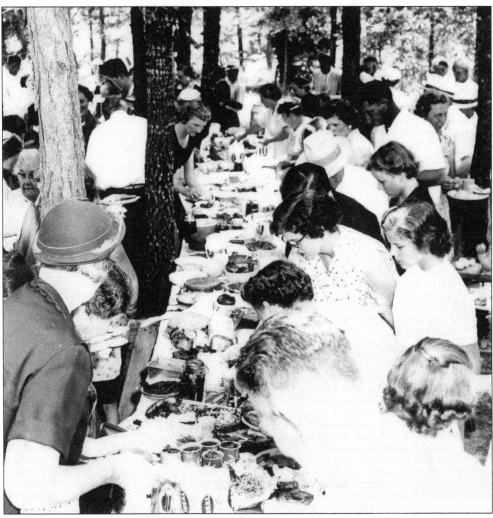

PICNICKING. Cherokee County's recreation has always been of the "homespun" variety, and children have participated equally with adults. Parades, rodeos, sports, and more offer county residents a respite from the workweek. Here those who helped at the annual homecoming at Providence Methodist Church, on FM Road 347, south of Jacksonville, enjoy a "dinner on the ground."

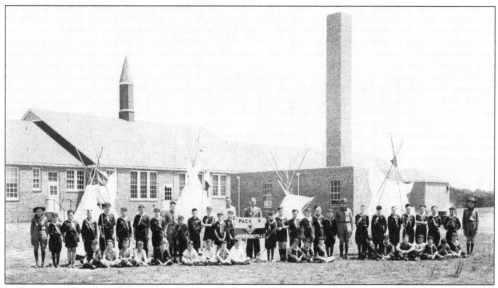

CUB SCOUT PACK 5. Recreation for boys often included scouting. This pack is participating at a local Jamboree held at the East Side School in Jacksonville in the 1940s. Principal Edgar Summerlin, behind the banner, was the pack's leader for several years.

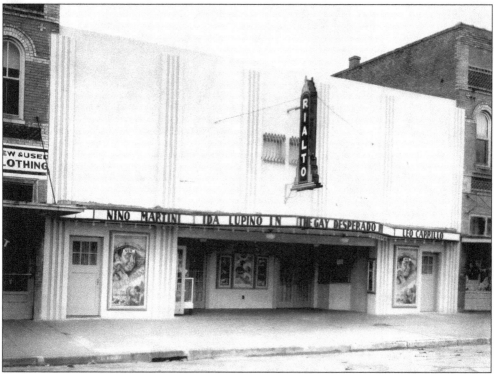

RIALTO THEATER. This theater on West Commerce Street in Jacksonville was the B-movie facility and superseded the Claire Theater a block east on the same street. The Rialto was operated to show second-run movies, which had been presented earlier in the Palace Theater, the chain's lead theater in Jacksonville, as well as movies of lesser rating, known as B movies. The theater closed around 1960.

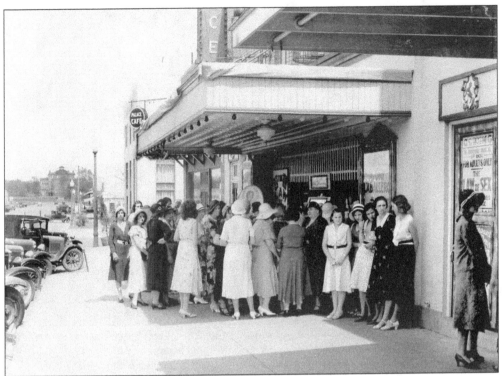

PALACE THEATER. The Palace was the premiere Jacksonville theater of the Jefferson Amusement Company. Opened in 1927, it lasted until the 1970s and was remodeled into offices in 1990. The women in this pre-1939 photograph await a ladies matinee. Note their hats and heels. At the far left is the old East Side School on Tomato Bowl Hill.

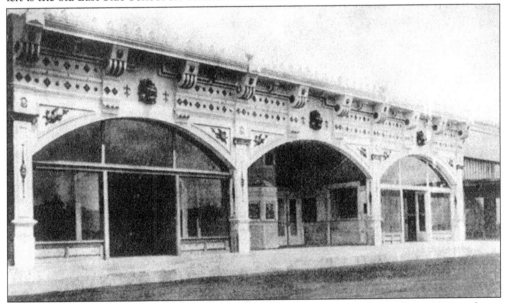

MAJESTIC THEATER. This theater on Busy Bee Street in Alto was built about 1910 and was patterned after the Majestic Opera House in Dallas. The theater burned in 1916 and was replaced by a less ornate building, which also burned.

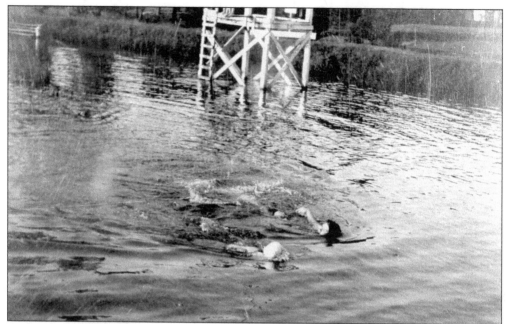

CHEROKEE PLUNGE. Swimmers enjoy a dip in the old Cherokee Plunge on the east side of Jacksonville. The pool was part of a recreational area operated from the 1920s until the mid-1930s by Ervay Coats. The facility included this swimming pool, a golf course, and a snack hut.

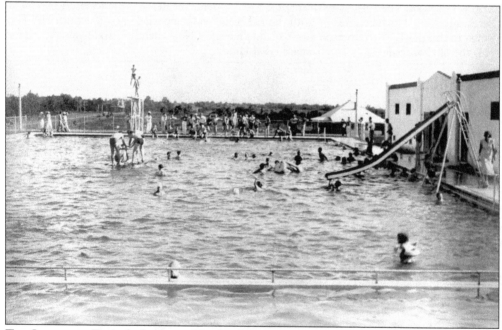

THE LOOKOUT. Typical of a day at The Lookout, a swimming and recreational spot at Love's Lookout Park north of Jacksonville, is this 1930s scene of people enjoying the pool. Opened in 1936 by C. J. Barbier and J. W. Garrett, the facility included a dance hall, concession stand, picnic tables, and similar installations. Mr. and Mrs. Ernest Hendrick operated the facility until it was closed in the 1970s.

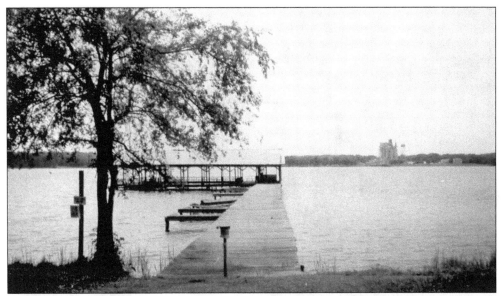

LAKE STRIKER. Developed by the Texas Utility Generating Company around 1950, Lake Striker never lived up to its billing as a recreational area. Primarily used as a source of water-powered electricity, the lake did sport a catfish cafe, camping, and picnic areas. Development of Lake Jacksonville in 1957 lured pleasure seekers away from this site.

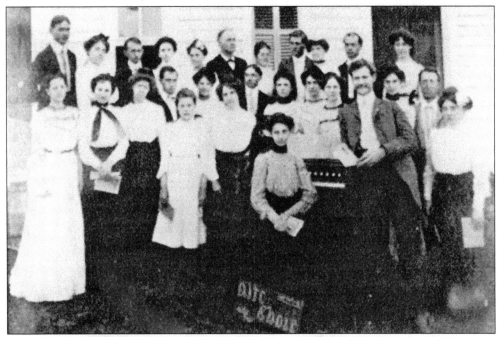

ALTO COMMUNITY CHOIR. As early as 1895, Alto residents entertained themselves with singing. Members of the choir, from left to right, are (first row) Clara Murphy, Eva Usher, Emma Musgrove, Jim Blanton, Mittie Pace, Edith ?, Ida Usher, Malone Armstrong, ? Thompson, Mary Fisher, Lizzie Tittle, Annie Fisher, Lovice Law, Ludy Findley, Will Blanton, and Betty Pace; (second row) Claud Coats, Ellen Pace, Robert Fisher, Annie Harrison, Bertie Jones, Reverend ? Pace, Mrs. Pace, Frank Pace, Ella Musgrove, C. Duke, and Fannie Fisher.

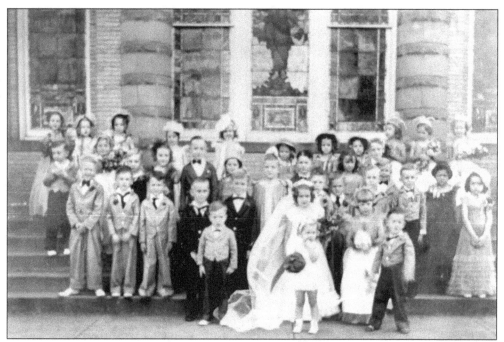

TOM THUMB WEDDING. This mock-wedding party on the steps of the First Presbyterian Church in Jacksonville was part of a fund-raiser during the 1938 Tomato Festival.

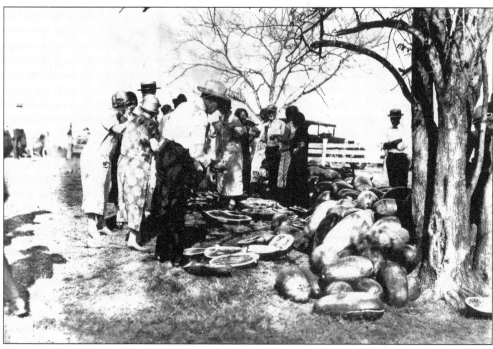

WATERMELON FEAST. One of the sure signs of summer in East Texas was the watermelon feast, in which friends and neighbors gathered at a home or church or family reunion to cut and eat watermelons right out of the melon patch.

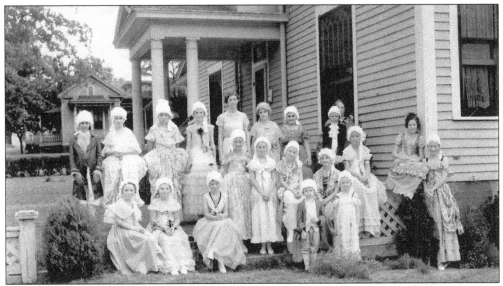

RECITAL PERFORMERS. The annual piano recitals by students of Mrs. Ralph McDougal were a musical highlight in Jacksonville. Recital participants wore colonial costumes for this event. Mrs. McDougal is shown on the right near a window, partially obscured by a student. The small boy in the foreground is John Tower, later a longtime U.S. senator from Texas.

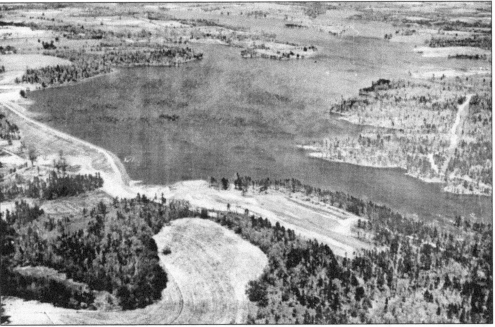

LAKE JACKSONVILLE. Jacksonville's newest water supply source was opened in 1957. This aerial view from the southwest shows the 472-foot-high dam in the lower right foreground with a view of the lake to the north and northeast. The City of Jacksonville funded the project to meet increasing demand of the town for water. Built during the 1950s' severe drought, unexpected rainfall filled the new lake in a short time. Water for the city is pumped from the lake to the filtration plant at Lake Aker, opened in 1926 in an earlier move to meet the increasing demand for water. The lake is a major recreation spot and is surrounded by many fine homes along the shores.

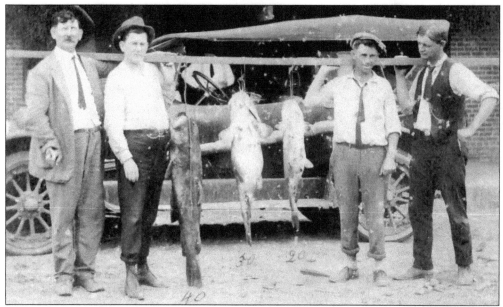

BIG FISH. Unidentified Jacksonville nimrods show off their big haul of catfish caught in the 1900s. The weights of the fish, from left to right, are 40, 30, and 20 pounds each. In earlier days, groups would go fishing and stay a week or more to fish, camp, and relax.

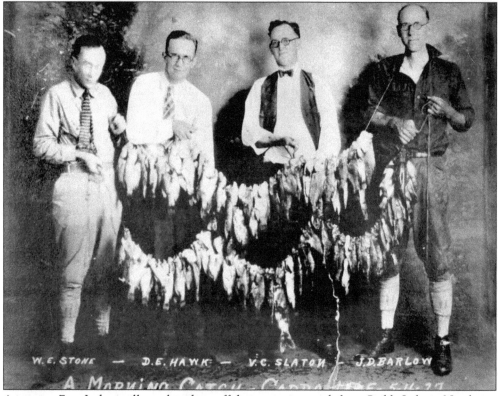

W. E. STONE — D. E. HAWK — V. C. SLATON — J. D. BARLOW

ANGLERS. Four Jacksonville anglers show off their morning catch from Caddo Lake in Northeast Texas in 1927. From left to right are W. E. Stone, D. E. Hawk, V. C. Slaton, and J. D. Barlow.

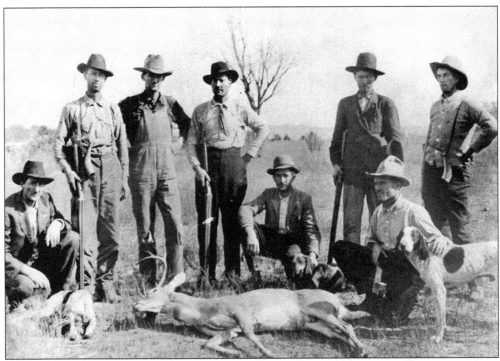

DEER HUNTERS. These eight hunters show off proof of their skill—a deer killed in 1912 in the Maydelle area. From left to right are John Benge, Dr. Will French, Felix Dover, Rufus Benge, Thayres Ezell, Mutt Stewart, Will Rainey, and Phil Ezell. Note the double-barreled shotguns.

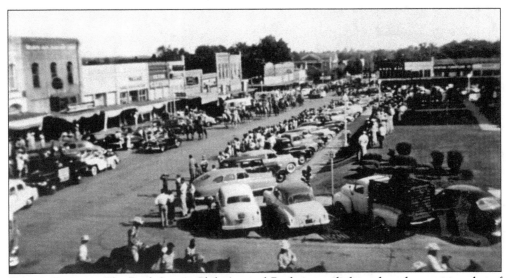

RODEO PARADE. The Rusk Lion's Club Annual Rodeo parade launches the opening day of activities in the early 1950s as it moves through the business district on Henderson Street. The courthouse is shown on the right as the parade moves southward. The rodeo was staged to help finance the club's various charitable activities.

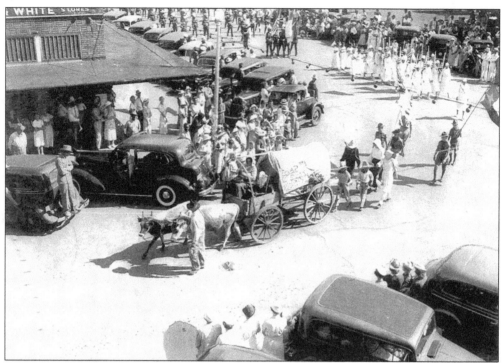

EARLY TOMATO FEST PARADE. This photograph of the June 1942 Jacksonville Tomato Fest Parade shows the Woodmen of the World Circle (Women's Auxiliary) with a covered wagon float at the intersection of Commerce and South Bolton Streets. The store whose sign reads "White Stores" is actually Brazil's Red and White Stores, long gone from the site.

SOUTHERN PACIFIC SINGERS. These young ladies formed the Southern Pacific Railroad singers in Jacksonville in the late 1920s and appeared in towns along the Southern Pacific lines on special occasions. From left to right are Janice Travis, Bernice Alexander, Helen Pruitt, Mary Alice Cobb, Kathryn Barber, Miriam Chessher, "Topsy" Neal, Marjorie Scott, Louise Stamps, and Imogene Beard.

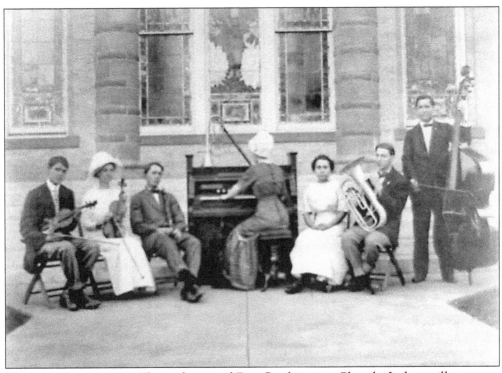

CHURCH ORCHESTRA. The orchestra of First Presbyterian Church, Jacksonville, was an accomplished musical group that played for church functions and most Jacksonville community activities for several years. Pictured on the front steps of the church about 1915 are, from left to right, Fred Ford, Jewel Brown, Audie Alexander, Maude McDougal, Bonnie Sory, Williard Newton, and a Mr. Emery.

OPENING PARADE. Jacksonville's National Tomato Festival, about 1937, opened with a gala parade preceding the elaborate pageant and coronation of the Festival Queen that evening. The float in this photo, traveling west on Commerce Street, carries princesses from neighboring cities. The festival parades were always outstanding, with various businesses sponsoring the elaborate floats.

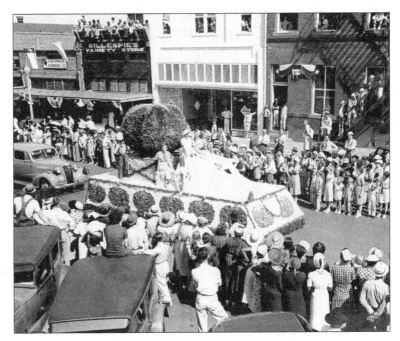

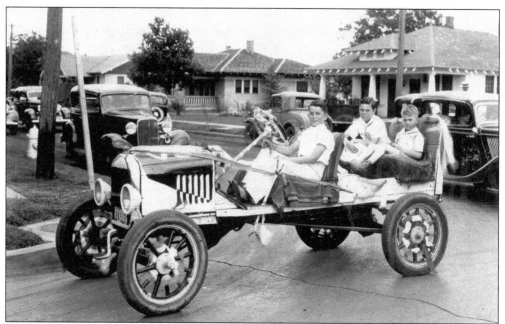

"Hoopie" Float. A cut-down Model T Ford, also known as a hoopie, is decorated and ready for the 1935 Tomato Festival parade in Jacksonville. Simple to drive without gearshifts, these cut-down vehicles were very popular. Driving this one at Austin and Elm Streets is George Brown. The other youths are unidentified.

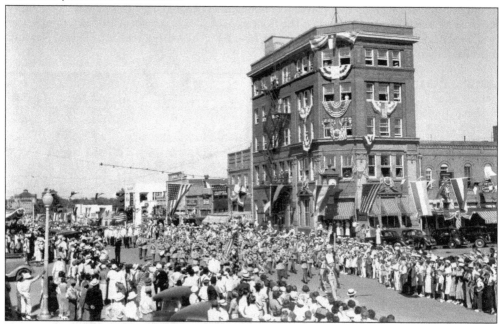

Festival Parade. This scene from the 1938 Tomato Festival parade in Jacksonville shows the business district packed with thousands of people. Note the clock on the old First National Bank building and the old-style streetlights installed during the city's 1926–1928 street paving and improvement program. Old East Side School is visible in the far left background where Tomato Bowl Stadium is today.

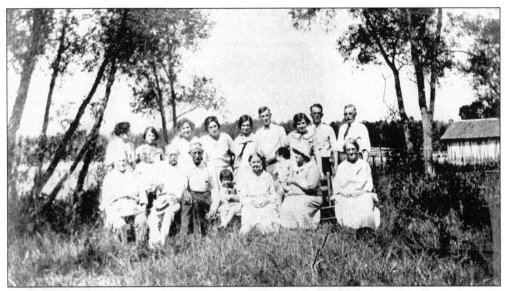

PICNIC. Picnics were a favorite recreational activity in earlier days, and entire church congregations and schools often held picnics each year. Here members of the Bolton family of Jacksonville enjoy such an outing. From left to right are (first row) W. C. Bolton, John Henry Bolton, Rev. Bartlett Bolton, unidentified child, Julia Ann Bolton, unidentified child, unidentified, and unidentified; (second row) Downes Bolton, Tracy Bolton, and the remainder unidentified.

EARLY JACKSONVILLE BAND. The Fraternal Brotherhood Band was a musical organization active in the early 1900s. The only people identified in this photograph are M. L. Earle (left) and John Allen Templeton I, both seated in the Victorian-style bandstand in City Park. This edifice was replaced with one of native stone in a 1930s WPA project and was consequently demolished in 1960s to make way for the current fire station.

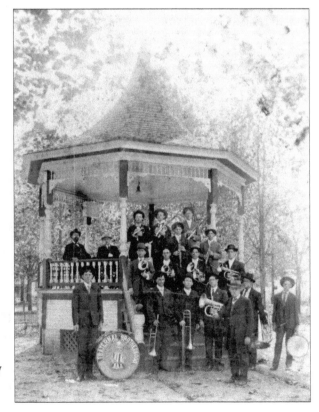

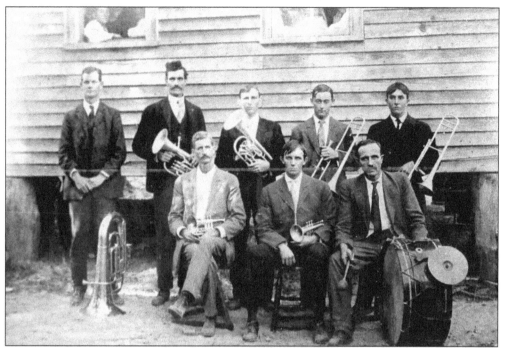

GENT BRASS BAND. These musicians provided music for Gent community activities as well as for nearby communities in the early 1900s. Posing in front of the long-gone Gent school building, from left to right, are (first row) James T. Holsomback, unidentified, and Bunn Huff; (second row) Clifford Nolley, Hubbard Odom, unidentified, Fayette Norris, and unidentified.

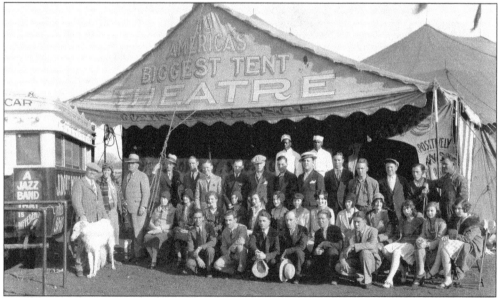

J. DOUG MORGAN SHOW. This tent show, one of the last traveling theater troupes in the business, headquartered for many years northwest of Jacksonville. The show initially traveled via railroads with its own cars and equipment before changing to trucks and automobiles with the advent of better roads. Usually the show followed the crop harvesting routes. A Mr. and Mrs. Morgan are on the left with a dog.

DIALVILLE BOYS TEAM. Small schools in the county could not afford football teams but every school had a basketball team. The Dialville High School boys team was always a strong contender for county championships. This 1936 photograph includes, from left to right, John McCarty, Bill Isaacks, Ernest Glass, Erwin Phillips, John Spivey, Charles Finley, Rudolph Sorrel, Edward Sewell, unidentified, Jewell Wallace, Carol Payne, and Coach Wilten Burns.

GIRLS BASKETBALL. This 1936 team from Dialville High School was as highly honored as the boys teams. From left to right are Bertice Marie Jones, Imogene Taylor, Mildred Hall, Mary Alice Harris, Louise Acker, Wana Reynolds, Imodean Acker, Lillian Durrett, Altha Onie Johnson, Hazel Dement, Maxine Sorrell, Lena Fulton, and Ottie Harris.

JHS 1917 QUINT. Jacksonville High School's 1917 boys basketball team seems a far cry from today's teams as it poses in front of the high school on Kickapoo Street. The team had only nine players, and their shoes and socks did not match. The basketball court was made of hard-packed clay and gravel. Gymnasiums did not arrive in Jacksonville until the late 1920s.

WELLS CAGERS. The 1934 Wells High School girls basketball team, from left to right, included (first row) Norma Harrison, Gladys Sessions, Annie Laurie McCullough, Hilma Wallace, Irma Dean Dew, and Mavis Warner; (second row) Maurine Wallace, Molly Dee Bowman, Lura Dell Ayers, Marie Hannah, and Doris Simmons; (third row) Mildred Simmons, Mrs. W. C. Wisener (coach), and Gladys Hester.

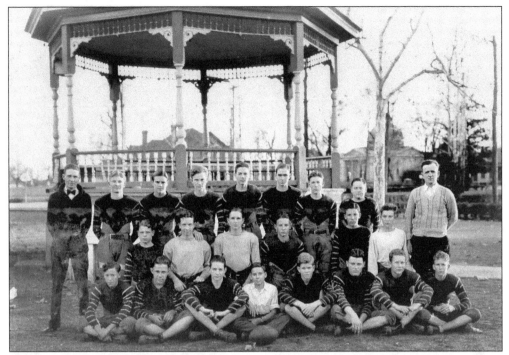

HATCHET GANG. The Jacksonville Boy Scout "Hatchet Gang" football team, *c.* 1930, from left to right, included (first row) Billy Jackson, Bernard Walker, Ed Tipton Jr., Pete Dublin, Charles Hurley, David Lambert, J.H. Holcomb, and John Ed Hallmark; (second row) Walker Payne, Evender Beverly, Edwin Flynn, Gus Moore Jr., Wilson Pickens, and Allen Hunt; (third row) assistant coach ? Walker, Wayne Boren, Wilton Show, Ronzo Wade, Crysup Sory, Ferdinand Dawson Jr., J. H. Quick Jr., Edwin Van Zandt, and Coach Godbey Acker.

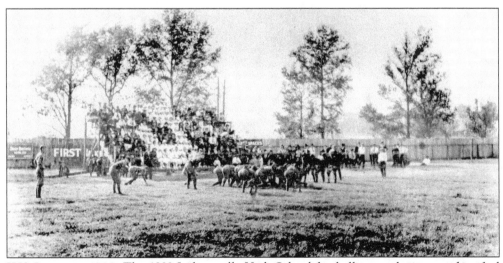

JHS INDIANS, 1922. The 1922 Jacksonville High School football team plays an unidentified team at the football field off West Pine Street and east of the high school, which faced Kickapoo Street. The site served also as a baseball park and track and field area for the school. The people in the stands wearing white are probably the team's pep squad.

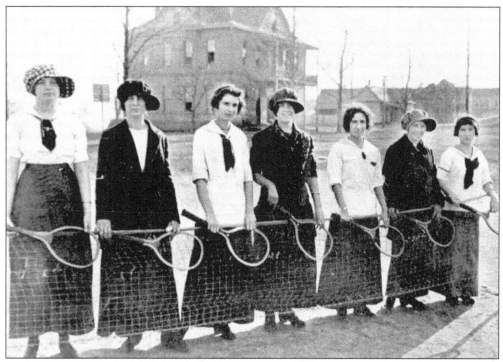

GIRLS TENNIS CLUB. The Jacksonville High School's girls tennis team poses on the corner of Austin and Rusk Streets prior to 1924, when the school building in the background was demolished in a storm. The buildings in the background eventually became part of the high school built on Neches Street in 1925. Note the tennis attire of the day.

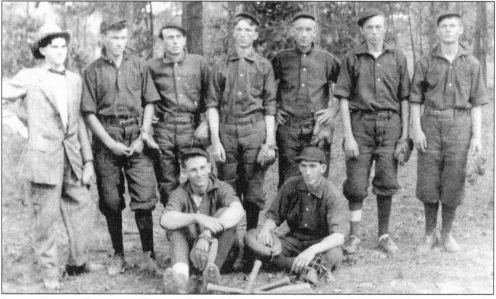

JONES CHAPEL BASEBALL TEAM. This *c.* 1909 community baseball team had a reputation for winning games. Jones Chapel was also known as Blackjack. From left to right are (first row) Miller Hoover and John Musick; (second row) Wash Landrum, Wood Holiday, Byrd Bice, Curtis Hendrick, Joe Moffett, Ben Holiday, and Cartney Killion.

Nine
WORSHIP

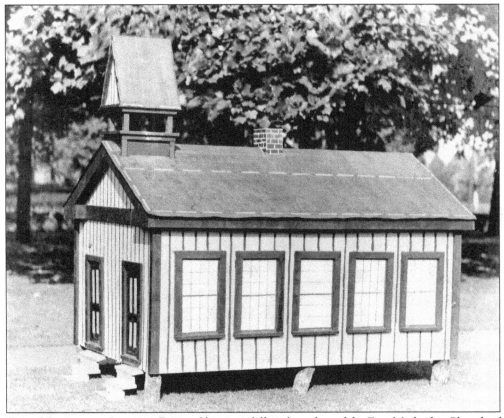

FIRST METHODIST CHURCH. Pictured here is a full-scale replica of the First Methodist Church of Jacksonville, built in the late 1870s on Patton Court. For many years, towns in Cherokee County boasted equal numbers of churches and gasoline stations. All the churches were "main-line" then. The trend today is toward many smaller, nondenominational churches. Still today, whatever the brand, county citizens attend church because of true religious fervor, for social and business reasons, or just because "it's what people do."

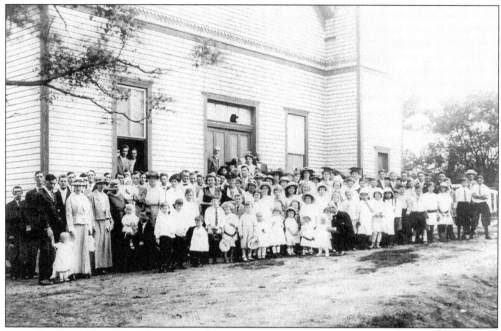

RUSK BAPTIST CHURCH. This 1915 photograph shows congregation members of the First Baptist Church in Rusk on Fifth and Barron Streets. The building was later replaced by a brick one.

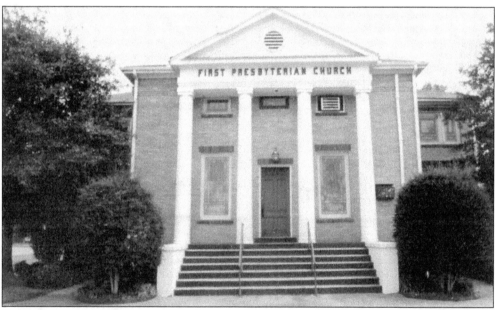

RUSK PRESBYTERIAN CHURCH. The First Presbyterian Church on Main Street in Rusk is one of the oldest congregations in the city. Note the stained-glass windows and the front steps—no longer popular with today's older congregations.

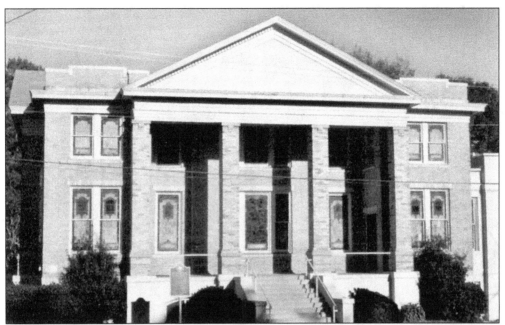

FIRST METHODIST CHURCH, RUSK. This building has occupied the same corner at Henderson and Fourth Streets for generations. The left section was added in 1920 and the right section in 1996, but the congregation has again outgrown the site and the building. A new church is planned near the edge of town.

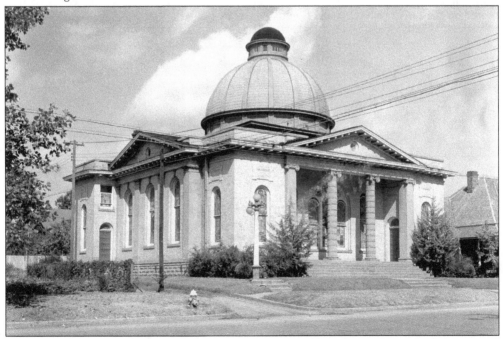

FIRST PRESBYTERIAN CHURCH. This congregation, established in 1871, erected this second building in Jacksonville on the same site as the first. Begun in 1910, the church was completed in 1911 and the earlier frame building sold to the Catholic Church. The house at the right of the church is the manse, the home of the pastor and his family.

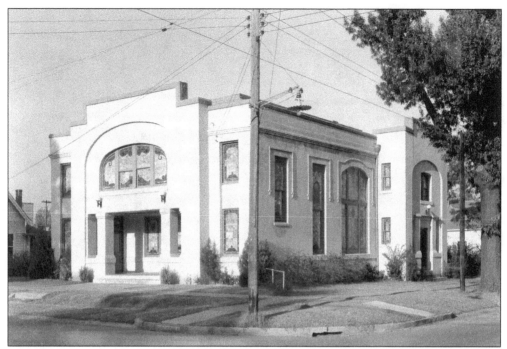

FIRST BAPTIST CHURCH. Jacksonville's First Baptist Church occupied this building from about 1911 until moving to the present site on Phillip Street in 1977. The congregation was organized in 1873 and immediately constructed its first building. The second building, pictured above, was located on the corner of Neches and Ragsdale Streets.

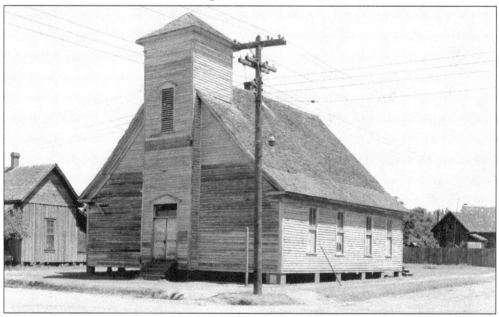

HISTORIC CHURCH. Sweet Union Baptist Church at Main and Pine Streets, Jacksonville, was the first Baptist congregation for black citizens in the town. Organized in 1875, it was originally located on what became the campus of Jacksonville College in 1899. The church moved to this site in 1900, where it continues to be involved in various school and community affairs.

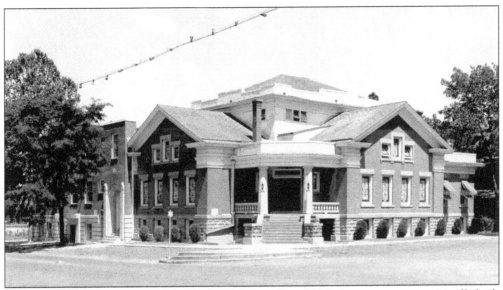

CENTRAL BAPTIST CHURCH. Organized in Jacksonville in 1906, the congregation originally built this structure in 1913 using the "Cleveland Plan" with a sub-basement for classrooms, a sanctuary above it with a balcony on three sides, and a corner front on Larissa and Main Streets. This building was replaced in 1958. The congregation moved to larger facilities in the early 2000s.

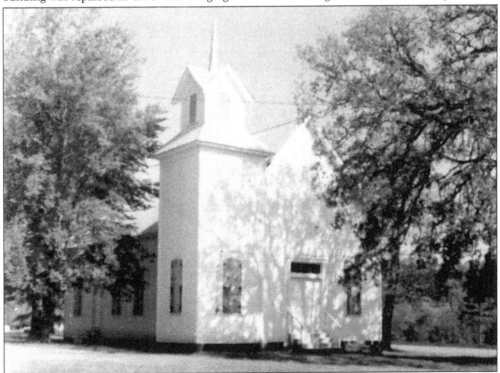

SHILOH CHURCH. Shiloh Methodist Church near Alto, one of the earliest Methodist churches in the area, nestles in its rural setting with the cemetery nearby. Founded in 1854, the church occupied several different buildings, from a log structure to this one, built in 1912, until 1954, when it was merged with the A. Frank Smith Methodist Church in Alto.

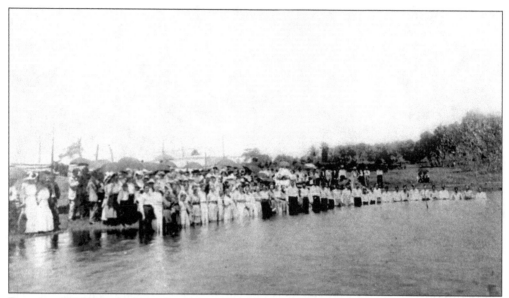

BAPTISM. Evidence that not all worship takes place in the confines of a building is provided by this large group of people, pictured about 1900, participating in a baptismal ceremony at Old Camp Wright near Maydelle in the pond on the Jim Arnwine farm. Outdoor baptism was typical of rural church activities and is sometimes enacted even today by those wishing a taste of that "old time religion."

CHEROKEE COUNTY, THE HEART OF TEXAS. This illustration shows the shape and location of the county.